Watercolor

WILD & FREE

PAINT CUTE ANIMALS AND WILDLIFE IN 12 EASY LESSONS

Natalia Skatula

DAVID & CHARLES

www.davidandcharles.com

Hello,

How lovely to see you holding this book full of brightly colored and mindful watercolor inspirations in your hands. Creating beautiful things on paper is one of my favorite pastimes. Like many others, I am often left feeling tense and stressed by the ups and downs of work and life in general. But painting gives me peace and tranquility. I see it as a form of mindfulness that brightens up my everyday life, and that's what I'd like to share with you in this book.

I hope that the pages of this book will inspire you to bring your own creative ideas to life in many ways. And don't be afraid of the blank page – inspiration is everywhere. You just have to pay attention to what is around you.

Yours,

Natalia

Tip:
I post little clips from my everyday creativity on my Instagram account @nataskalia.

Contents

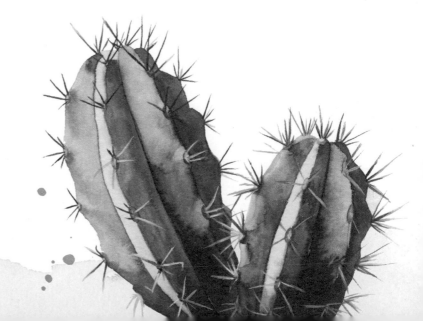

Before YOU Begin...

Before you set about your first project, take a little time to have a brief look at watercolor painting. This section will give you useful information about how to get started and what to do about pencils, brushes, paints, and paper. It's only by having a good understanding of the materials you will be working with, and their functions and capabilities, that you will achieve the results and effects you are looking for.

WATERCOLOR PAINTING

Watercolor painting is a very exciting and sometimes unpredictable technique. It is possible to paint with great precision and detail with watercolors, but they can also be used to produce spontaneous color sequences that are pleasingly imperfect. Depending on how much water you use, the water-soluble paint will run rapidly in different directions over the paper, producing totally unplanned and unique splashes of color. This is precisely what is so fascinating for me with my watercolor work – the interaction of the random patterns of color and small detailed touches, from which a finished picture emerges.

When you make your initial sketches, never copy your reference picture in exact detail. It's much more about creating small new worlds of color, allowing the interaction of water and color to take its course and seeing what comes out of it.

It doesn't matter whether it's a bear wearing a hat or a sloth hanging in the vines – the main thing is that we're plunging into a world of form and color that makes us happy and enriches our everyday lives with creative inspiration.

MATERIALS

Getting started with watercolor does not require a lot of equipment. You will normally only need:

· pencil
· eraser
· brushes
· paper
· watercolors
· absorbent cloth or paper towel
· glass water container

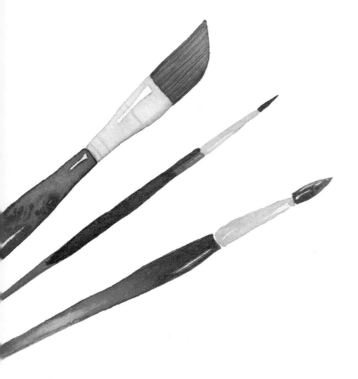

Brushes

Considering the wide selection available and the differences in price, finding the right brush may seem daunting, but it does not have to be. Natural hair brushes are normally more expensive than synthetic ones. Your brush should essentially be capable of absorbing water well and holding it. It should be flexible and regain its shape after each brushstroke. It is also important that the fibers do not crumple up after the brush has been used for dabbing splashes of paint or drawing lines. There are basically two types of brush – round and flat. A round brush, where the fibers form a point, can be used to produce both fine and broad strokes, depending on how you apply the brush to the paper. This also applies to flat brushes, which are particularly suitable for larger areas such as backgrounds. Some of my favorites are the Cosmotop Spin series of round and flat brushes from da Vinci, which are very soft and don't fray easily. Three or four brushes, ranging from fine to broad, should be enough to get you started on various projects. I recommend round brushes in size nos. 0, 3, 5 and 8 or 10.

Tip:
Clean your brushes regularly under running water. This will keep them in good condition and ensure they last for a long time.

Paper

Choosing the right paper is extremely important. Above all it must be absorbent. The various types of paper are distinguished by their grain size, which in turn depends on the texture of the paper, and by the paper thickness, which is stated in grams per square meter. Lightly grained paper has a smooth surface, whereas coarse-grained paper is rough. Every type of paper has its advantages, so you should try them out for yourself. Coarse paper is obviously more structured, producing a color effect that is different from the more detailed work you can easily achieve on fine or smooth paper. The thicker the watercolor paper is, the easier it is to paint on, as it is more absorbent and less likely to curl up or lose its shape.

I like working with Hahnemühle Britannia watercolor paper, which has a density of 300g/m² in matt. This paper is about 200g/m² heavier than normal drawing paper, where the normal weight is 100-150g/m². It is extremely absorbent and robust, and it allows me to do any kind of watercolor painting, whether it's delicate, detailed, or broadly expressive.

Tip:

Watercolor pads that are glued on all four edges work extremely well, because the paper does not curl up when you are using a lot of water. Carefully separate the paper with a knife or ruler once the painting is dry.

Pencil

You'll need a pencil for your sketches. It's best to use an HB pencil for this as it will give you a fine but clear line that's easy to erase.

Eraser

A soft rubber eraser is recommended as it is the least likely to damage the surface structure of the paper when used. I like using the Faber-Castell kneadable eraser.

Cloth

An old cloth or some paper towel can be worth its weight in gold. For one thing, you can always wipe your brush on it. And what's more, it helps you deal with minor accidents or disasters. If, for example, you have applied too much paint to a surface, you can easily dab it off or wipe it away with a cloth.

Tip:

A clean brush is also good for wiping away unwanted paint.

Watercolors

Watercolors vary in quality and come in various forms, for example in pans or tubes. Single watercolors in tubes are more concentrated than the hard paint in pans. The latter has to be moistened with a wet brush before you start in order to release the paint, which is then automatically diluted. Whichever you choose is a matter of taste.

I used Schmincke watercolors in pans for the projects in this book. A small box of watercolors with a medium range of colors is enough to get started. Other colors can easily be mixed from the basic colors.

Exercises

A few simple exercises can help you become more confident with the materials you're working with. Try out brushes and paints on different types of paper. You will soon see how your materials react under different conditions and how much this can affect the results.

Dip any brush you like into clean water, to get it wet, and remove any excess water against the rim of the water container or with a cloth. The brush should be saturated with water but should not drip. Now moisten and absorb the paint from the pan with the wet brush, by moving the brush over the pan several times until the paint softens and permeates the brush fibers.

Draw a line with the brush. You might like to begin with the widest flat brush and work your way down to the finer brushes, drawing more lines with the other brush sizes as you go. You will find that fine brushes absorb much less paint than the broad ones.

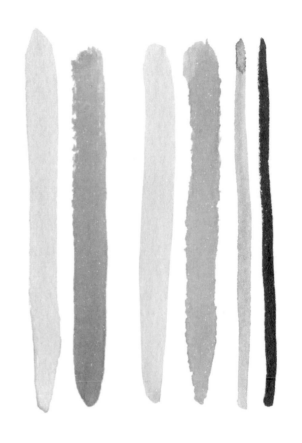

COLOR AND WATER

Playing around with the paint and water will help you gain more experience of watercolor painting. If you use a lot of water and not much paint, the tone of the color produced will be transparent, pale, and subtle.

If you mix the paint with just a little water, the tone will be dark and vibrant.

The exciting thing about watercolors is that they run into each other in a way that cannot be predicted, and this can produce fascinating and unusual color sequences. The results are completely different every time, depending on how much water you use. You need two essential painting techniques for watercolor painting: washing and scumbling.

Tip:

You can use the lid of your box to mix the paints, but ceramic or plastic artist's palettes can also be used.

WASHING

The washing technique involves applying wet paint to moist paper and allowing the colors to run into one another. The moistness of the paper is crucial. If the paper is very moist, the color spreads easily. If it's too dry, the color will not spread on its own. If you use too much water, the color may just puddle on the paper. This is not necessarily a bad thing, but the paper will then take a really long time to dry. It's important to find the right ratio of color to water.

Exercise

Paint an oval shape in a light color using a lot of water on previously moistened paper. Dab a little paint with a deep color at the edge of the shape. The dark color will spread. The farther the paint spreads, the lighter the tone becomes.

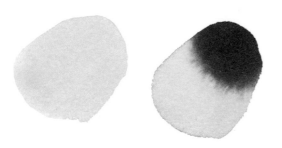

You can also use the washing technique on dry paper by creating the color run with a brush. Using a strong color that is not too moist, paint the outline of a circle on dry paper. Rinse the brush, wipe away excess paint, and water the circle down. Then paint with the brush from the edge of the circle towards the center. The color at the edges is loosened and becomes lighter and lighter towards the center. The contrast of light and dark produced by this technique gives your illustration a feeling of space and more dimension.

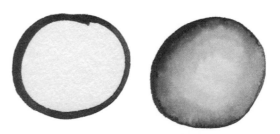

SCUMBLING

Scumbling involves painting a transparent layer of color over an area of color that has already dried, so that the lower layer shows through the upper layer, creating a translucent effect. To stop the colors running into each other, the lower application of paint must be completely dry. The colors blend together on the paper at the points where the colored areas overlap. The light sections visually recede into the background, whereas the dark sections appear more prominent.

Both scumbling and washing help you create an impression of space. If you combine the two techniques in one painting, the effect will be more varied.

Exercise

Paint a light red circle with well diluted red paint. Leave it to dry completely. Apply a second circle over it, offset from the center, in yellow. An orange area will appear at the point whether the colors meet.

You can also use the same color to produce tones of different strengths and intensity at the points where the layers overlap. The more layers of color overlapping one another there are, the more intense the color appears.

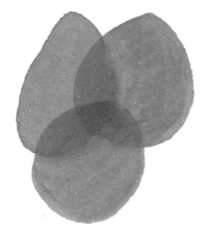

WHITE AREAS AND TRANSPARENCY

As you add more water, the color will become more vibrant, brighter and more transparent. The color that is diluted the most will be the most transparent of all. The whiteness of the paper can be seen most clearly through the lightest color tone. As the color tone becomes denser and darker it becomes less transparent.

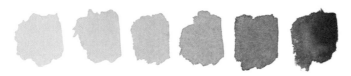

You can intentionally pick out light areas in your illustrations by leaving certain sections blank. These white unpainted sections act as points of light or light reflectors and make what you have painted appear more authentic and lifelike.

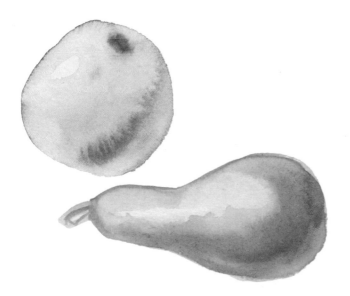

You can also use specifically targeted white patches to separate certain areas so that parts of the illustration are more clearly defined.

In watercolor painting it is difficult to add white points to applied paint, as the colors are sometimes still soluble on the paper even when dry. Equally, it is not usually possible to coax out a clear white from under the painted color. So, it is particularly important to think about the white areas beforehand and leave them blank.

Tip:

In certain cases, minor highlights such as fine points of light in the eyes can be added later using a white Uni-Ball Signo pen.

A LITTLE LESSON IN COLOR

Mixing colors is often a challenge, particularly for beginners. The three base colors – yellow, blue and red – also known as primary colors, can be used to produce all other colors. Mixing two base colors produces what are known as secondary colors, for example green, from blue and yellow. If you know how the individual colors react when combined with others, you will be able to produce an extremely nuanced palette of colors. The end result is determined by the proportions of the different colors that you use.

If you mix too many colors together you will end up with a sludgy brown or gray. So start by mixing two colors. Use the lighter tone as the foundation as it is usually very difficult, if not totally impossible, to lighten dark colors. Try different series of colors by blending two colors of your choice and then observe the color transitions and nuances that emerge. You can do this either by mixing two colors in the box and applying the resulting color to the paper or by allowing two colors to run into one another directly on the paper.

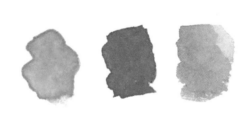

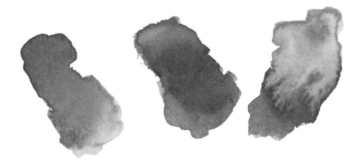

Tip:
Before starting your illustration, try out possible color combinations on some jotting paper, which will enable you to see which colors go well together before you start. In addition, testing paints and brushes will give you more confidence in handling the materials you are working with.

COLOR SCALES

A color scale is a group of colors that work particularly well together. This harmony of colors can be seen in shades of one color that are produced by the juxtaposition and blending of similar and related tints.

Cold colors

The colors produced from the primary colors yellow and blue form the cold range of colors. However other colors may also be added to the color scale, provided they do not start to dominate, but link into a harmonious common theme. For example, if a little red is added to a blue tint, violet is produced.

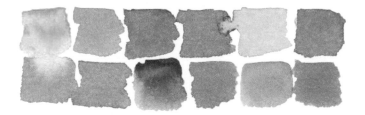

Warm colors

The warm colors include various red and yellow tones, and the color blends obtained from them. Again, it is also possible to add colors from other scales, such as a little blue, in order to diversify the warm tones.

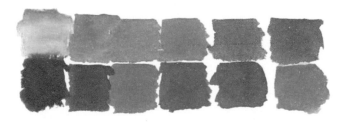

Broken colors

Broken colors are the dull, brownish-gray tones obtained from mixing together two secondary colors or a secondary color with a primary color. This color scale can be both warm or cold.

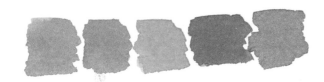

Tip:
Your illustrations will appear particularly harmonious and natural if the colors are repeated, either in the colors of the various elements of the image or within the colors you are using themselves. For example, if I'm painting a red apple with a green leaf, I might add a little green to the red of the apple and vice versa so that the colors work better together and appear to be linked.

MY 10 PERSONAL TIPS

1 You need practice and experience to achieve the results you want. Start with one technique and develop your skills step by step. Give yourself time.

2 Preliminary sketches are important: they help you shape your watercolor illustration and act as a guide. A pattern of your design may be helpful in bringing your painting project to life. For example, when you start out on a project, do some practice sketches on a spare piece of paper to get a better feel for the shapes and proportions.

3 Tracing is allowed! This method will help you reproduce the shapes of your design and transfer them onto the paper. This is of course rather difficult, but not impossible, with thick paper. Detach a sheet from your watercolor pad and hold it up against a window over your pattern. The light from outside will make the lines of the pattern show through the watercolor paper, allowing you to transfer them to the paper with a pencil. You can then secure your watercolor paper to a firm surface with masking tape to prevent it from becoming corrugated when you paint. An old wooden board would be a suitable surface.

4 You can also transfer your pattern directly onto the watercolor paper by blackening the back of your pattern with a pencil. Then fix the pattern paper with the blackened side onto the watercolor paper and trace over the lines of the pattern with a hard pencil. The lines will be pressed through the pattern onto your watercolor paper. However, take care when using this method as there is a risk that the pressure applied with the pencil may produce visible grooves in the watercolor paper.

5 Another way of transferring your desired pattern onto the paper is to use a prepared stencil, which will enable you to draw in the rough outlines of your design. Print off a design pattern, cut it out and lay it on the paper. Take care to ensure that your pattern stays firmly in place and does not slip when you draw around the contours of the stencil.

6 Don't lose heart if something doesn't go to plan. Success takes practice and you can only learn by trial and error. As you get more familiar with your working materials you will become more confident and feel better working with them.

7 Work with the light-dark contrast to create a feeling of space in your picture. The use of other contrasts can also strengthen the impact of your illustration and create tension (warm-cold, large-small, soft-hard, etc.).

8 As you work, pay attention to how much water and paint you are using and their relevant proportions. Wipe off excess water and paint to avoid unwanted puddles or blobs and prevent the color from running. You can make things easier for yourself by using a thin black fineliner pen or colored pencil for delicate parts of your picture, such as eyes – if you use your brush, too much water or paint can soon make the color run when applied to the paper, and the results can be anything but delicate.

9 When making your preliminary sketch, focus on the essentials by simplifying the lines and contours of your design. Try not to lose yourself in the details. My old art teacher once said: "Paint what you can see and not what you think you should be seeing."

10 Your style of painting will develop with time, just like your handwriting. The more you try to draw your designs with a free hand, the more successful you will become. Find out what you are capable of with a lot of practice, patience, and composure.

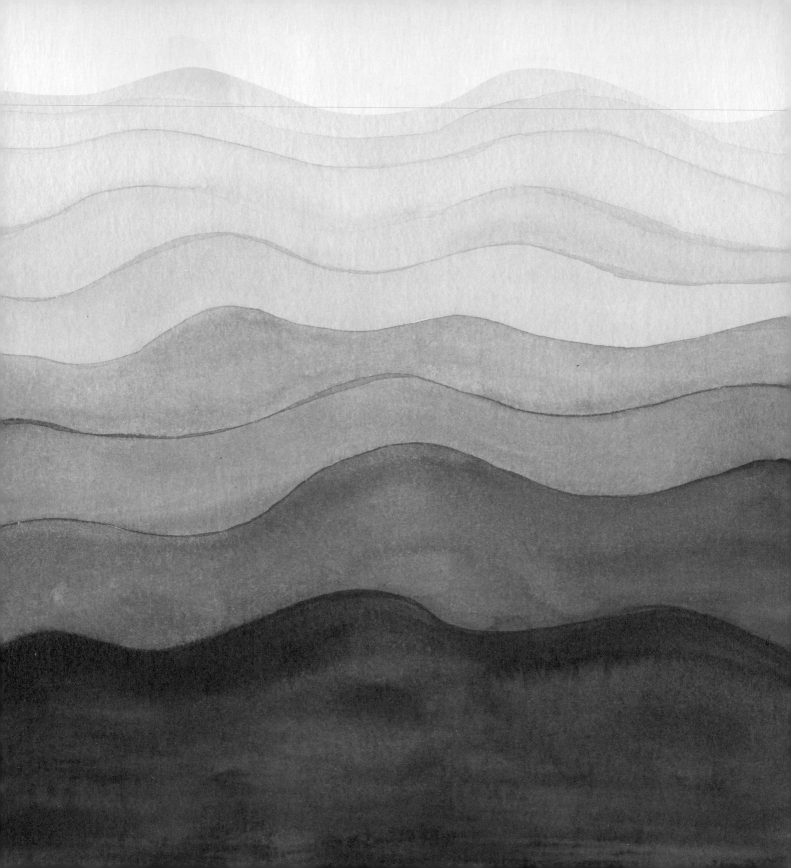

THE
Projects

Now you can get started: here are some inspiring ideas for your own painting projects. Have a go at wild and colorful illustrations that will make your home unique. Or give them to your loved ones. Whether they are posters, postcards or gift tags, the main thing is you are testing yourself and having fun at the same time.

Humpback
Whale

Who has not felt that feeling of "yearning for the sea" – a feeling of longing for some downtime, preferably somewhere by the shore? The relaxing murmur of the waves, the crunch of the sand under your toes, and the added delight of a gentle breeze. The things that are hidden in the infinite depths of the ocean can be just as beautiful and thrilling. This project enables you to bring it all into your home. Choose paper that is in a nice poster format on which the whale and the paint will have enough room to spread out or pick a small postcard to send in the post.

YOU WILL NEED:

· pencil
· ruler
· eraser
· round brushes, nos. 0 and 5
· watercolor paper, matt, 300g/m², size 9½ x 12½in (24 x 32cm)
· watercolors, see palette
· Uni-Ball Signo pen, white
· cloth
· glass water container

1. All the focus here is on the humpback whale, so begin by drawing the curved outer lines of the whale, positioned centrally on the paper. Then slowly work inwards on the other features, i.e. the eyes, flippers, and stomach. Rough outlines will be sufficient as the watercolor paint will do most of the work for you.

2. When you are happy with your sketch, it's time to start painting. But don't forget to rub out the pencil gently with an eraser beforehand, so that no unwanted dark lines are left to show through the paint.

787 670 656

My color palette for this project, see page 110

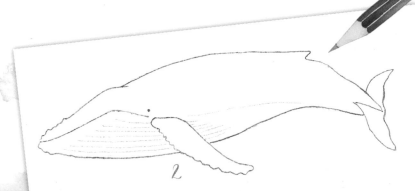

2

3. A limited color scheme will help you give shape to the painting. Try out a few blue tones on a scrap piece of paper, combine some of them together and then decide which shades you would like to use for your humpback whale.

Tip:
Try not to apply too much pressure with the pencil, otherwise the lines will be more difficult to rub out before the color is added. It may also create grooves in the paper, having an unattractive effect on the color.

4. Begin by painting the entire surface of the whale – down to the white area of the stomach – with one or more blue shades. Play around with the paint and water to achieve your desired effect.

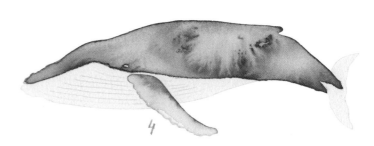

5. At the points where the whale should be lighter, add some water with the brush and gently nudge the color towards the outline. To do this, dab a moist brush into the paint that has already been applied to the paper and see how varied color runs are created.

6. Work on the areas where the whale is in shadow with darker, less diluted paint. You can do this by picking up the paint with a lightly moistened brush and carefully dabbing at the relevant parts of your design. Now it's a matter of waiting until the paint is completely dry.

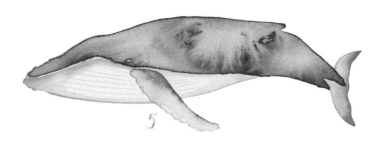

7. Now we get to the finer details. Using a thin brush (for example, a size 0) trace the lines on the stomach, the flipper and the eye. Take care to ensure that the paint picked up with the brush is not too thin, otherwise the fine lines will not work and unintended color runs will be produced.

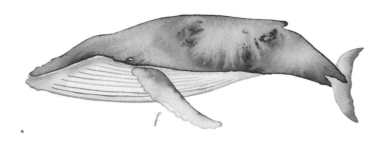

8 Next add white highlights with an opaque white pencil or white paint. I have used a Uni-Ball Signo White pen here to paint in the line of the mouth, the spaces between the lines on the stomach, and the barnacles on the flipper to make them stand out.

9 Finally, add a slight shadow to the white barnacles, to make everything appear more natural and provide more dimension. To do this, add a slightly diluted shade of blue-gray to the appropriate places with a fine brush. Our new underwater friend is finished.

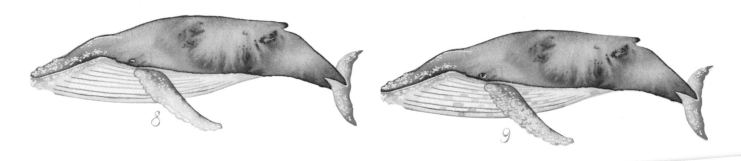

Tip

Begin a flat expanse of color with soft, light colors. It's easier to add dark colors gradually than the other way around.

See pages 96-98 for more whale designs

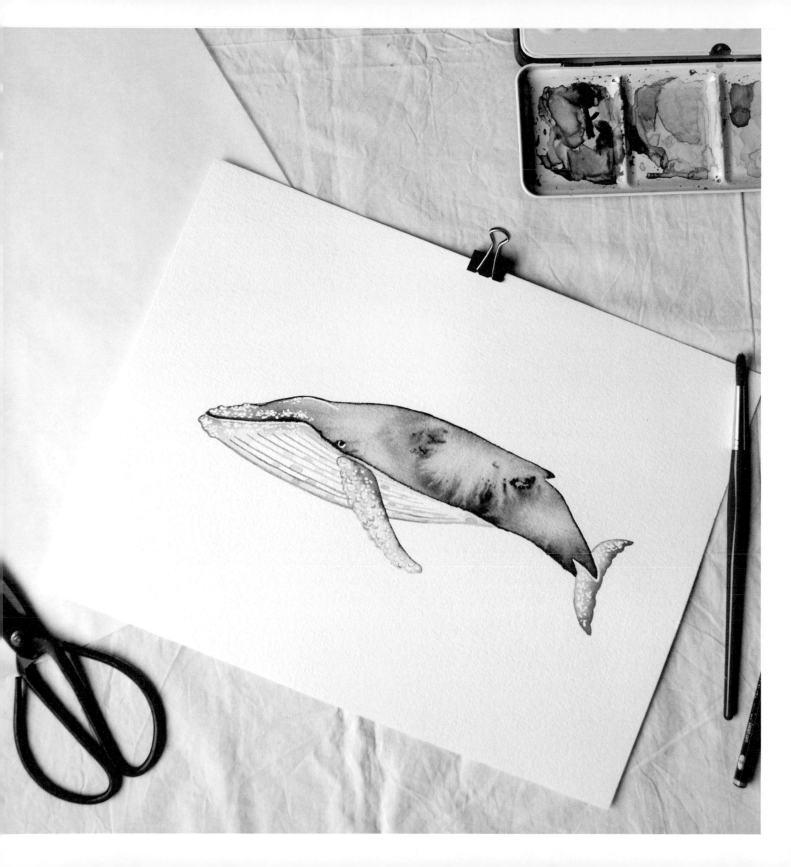

Sweet
Watermelon

Watermelons make us think of summer, sunshine, and holidays. Feel summery at home all year round when you enjoy this fruity illustration.

YOU WILL NEED:

· pencil
· ruler
· eraser
· round brushes, nos. 3 and 8
· watercolor paper, matt, 300g/m², size 7 x 9½in (18 x 24cm)
· watercolors, see palette
· fineliner pen, black
· cloth
· glass water container

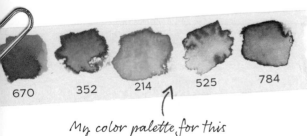

670 352 214 525 784

My color palette for this project, see page 110

1 To help you place the melon design centrally on the paper, draw thin lines with a pencil and ruler at the left, right, upper, and lower edges. Then draw a semi-circle roughly in the middle of the markings, so that it resembles a slice of melon.

Tip:

Always have a cloth to hand so that you can dab off any excess paint, if necessary.

2 Begin adding color to the red flesh of the fruit, using the washing technique. To do this, apply light and dark red tones to the damp paper while they are wet. Unique color gradations will form as the colors run into one another.

3 The outer green skin of the fruit is also produced by washing. Apply a transparent green tone to the skin area, using a lot of water and very little paint. Then get a somewhat deeper green tone on your brush and dab a little here and there along the outer edge of the skin. The color will slowly begin to run into the light green tone. When you are happy with your color effect, leave it all to dry completely.

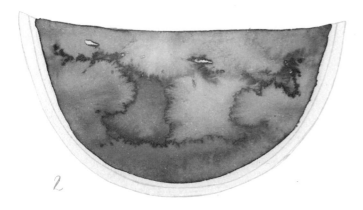

2

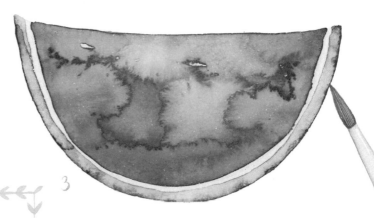

3

Tip:

Leave a white space unpainted between the red flesh and green skin of the melon. That way you won't have to wait for one of the two colors to dry before you continue painting, as the colors can't run into each other.

4 Sketch in the teardrop-shaped seeds of the melon with a pencil. Keep your pencil lines as light as possible so that they are easy to rub out and don't leave any traces on the watercolor paint.

5 Carefully color in the seeds with a black fineliner pen.

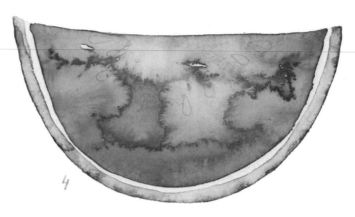

4

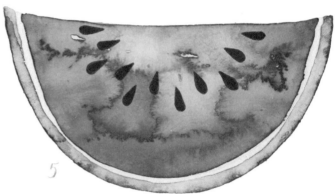

5

Tip:
If you think your finished watermelon is too small in relation to the size of the paper, or it isn't positioned centrally, don't despair. Simply adjust the paper to your design. The same thing happened to me with the melon painting shown here – it just looked too small when it was finished, so I decided there and then to trim the paper to a more suitable size.

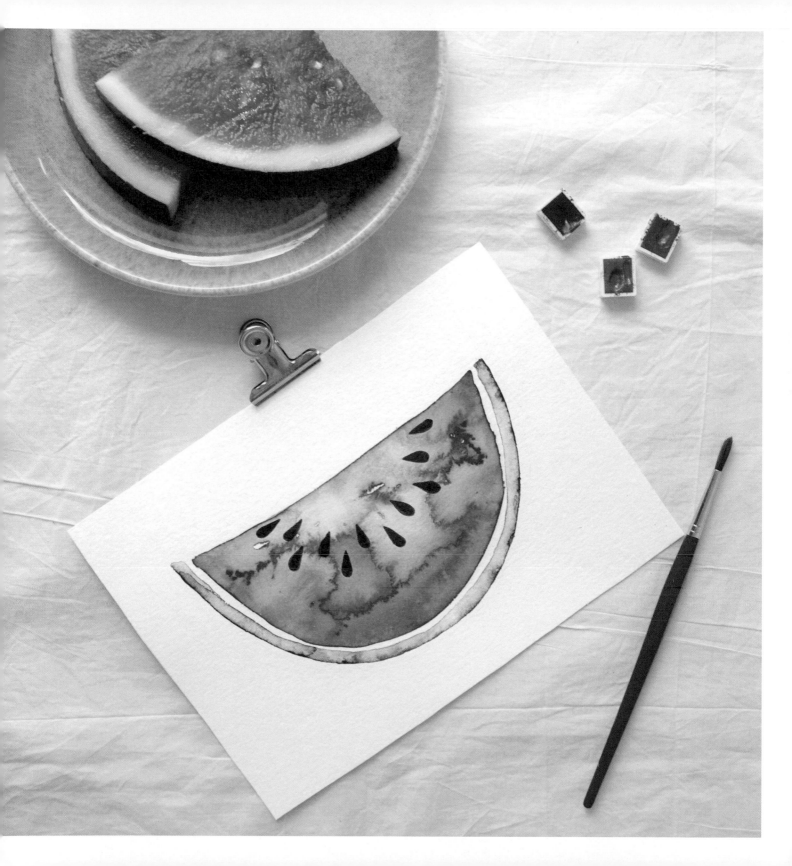

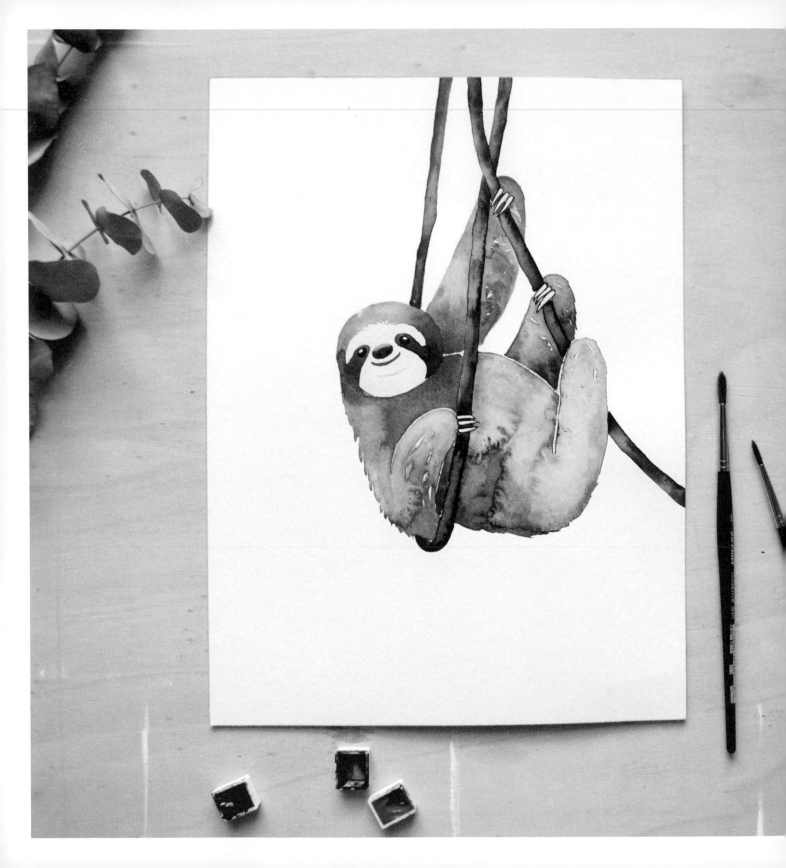

Cheerful
Sloth

This cute sloth. looking so peaceful and relaxed hanging in the vines, can also hang serenely on the wall of your home with this project.

YOU WILL NEED:

· pencil
· eraser
· round brushes, nos. 5/0 or 0 and 5
· watercolor paper, matt, 300g/m²,
 size 12½ x 9½in (32 x 24cm)
· watercolors, see palette
· fineliner pen, black or gray
· cloth
· glass water container

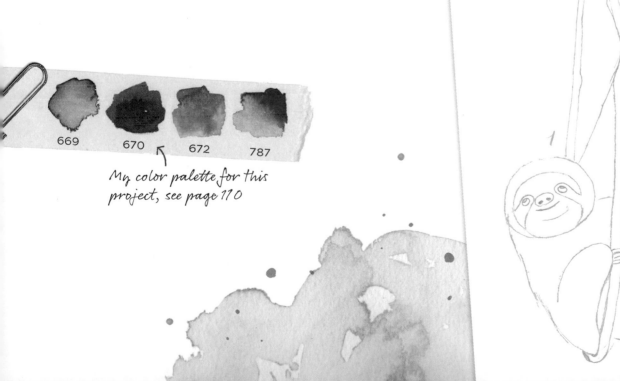

669 670 672 787

My color palette for this project, see page 110

1 The sloth is the central theme of this poster project, so place it towards the middle of the page. Draw a simplified outline of the design, starting with the horizontal, oval body in the center of the paper. Be sure to leave room for the upstretched limbs and the hanging vines above it.

2 The sloth's head is also round to oval, the eyes are wide apart and the arms and legs have three claws each.

3 Before you start painting, soften the pencil lines by rubbing them away slightly with the eraser.

4 Now start to paint the individual body parts in sections, one after the other. Use a light brown shade, mixed up with a lot of water, as a base layer. While the paint on the paper is still wet, fill in the shadows with shades of varying intensity, by dabbing them onto the paper. You can see how the colors spread during this process. Note that the eye sections, as well as the nose and mouth, are particularly dark.

Tip:

Using shades of varying intensity makes the illustration appear more three-dimensional.

Tip:

Leave small areas of the sloth intentionally white. These blank areas will give the fur texture and vitality, as they act as light reflectors and reinforce the visual appearance of the shaggy fur.

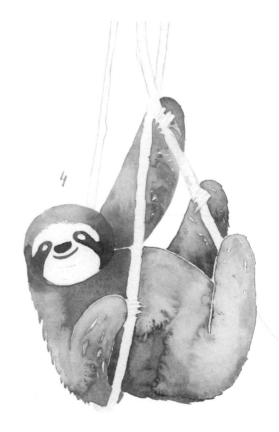

5 As soon as the sloth is dry, color in the vines with a brown shade that is different from the sloth's fur. You can paint in the eyes and nose with a dark blue that is only slightly diluted. Watch out for the two light points in the eyes, which should be left blank.

6 Finally draw in the claws with a black or gray fineliner pen, so that they are clearly visible and don't disappear under the fur.

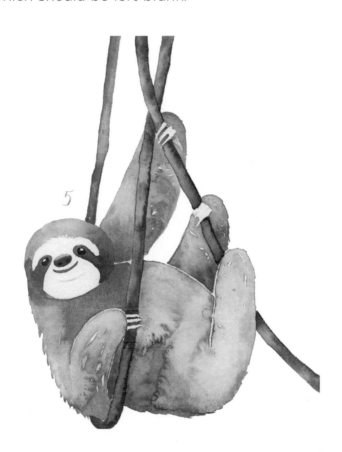

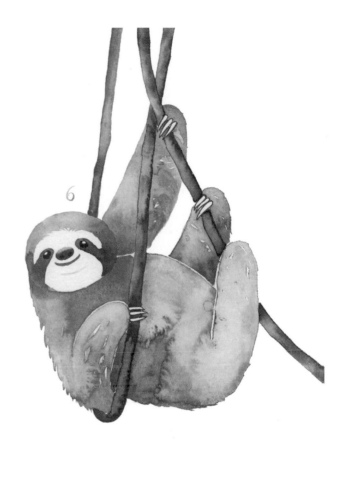

Tip:
If the color of the eyes runs, you can add the points of light with white paint or a white Uni-Ball Signo pen once your painting is dry.

Urban Jungle
Gift Tags

If you want to add an extra personal touch to a present, these three gift tags with popular tropical plant motifs are just what you need. Whether it's for a birthday, Mother's Day or to decorate a thank-you gift, your watercolor gift tags will be really eye-catching. Find out how to create them here, in just a few easy steps.

YOU WILL NEED:

· pencil
· ruler or set square
· eraser
· round brushes, nos. 5/0 or 0 and 3
· watercolor paper, matt, 300g/m², smallish scraps
· watercolors, see palette
· fineliner pen, black
· cloth
· glass water container
· small glass or cup

Monstera

1. The leaf shape of the Monstera, or Swiss Cheese plant, fits neatly onto a round tag. To draw a perfect circle for your tag's outline, use a round glass as a guide: place it on the paper and draw around it with a pencil.

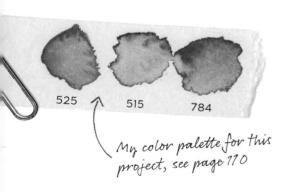

525 515 784

My color palette for this project, see page 110

Tip:
Bear in mind that the colors will also evolve and blend during the drying process. The appearance of the wet paint is not necessarily the end result.

3. Apply a light green shade, using a lot of water and very little paint, over the entire leaf. Now dip your brush in a somewhat deeper green and dab it along the outer edge of the leaf. The darker green will begin to spread within the light green and blend with it.

4. Last of all, when the paint is completely dry, add the stem of the Monstera leaf in a mid shade of green.

2. Now make a simplified sketch of the typical Monstera leaf shape in the center of the circle.

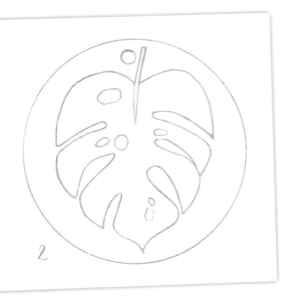

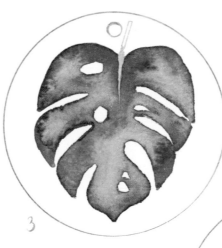

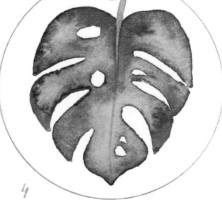

Tip:
If you would like lighter areas on your plant, dab the still-moist paint that has already been applied with a cloth or nudge it along with a brush dipped in water to the desired point.

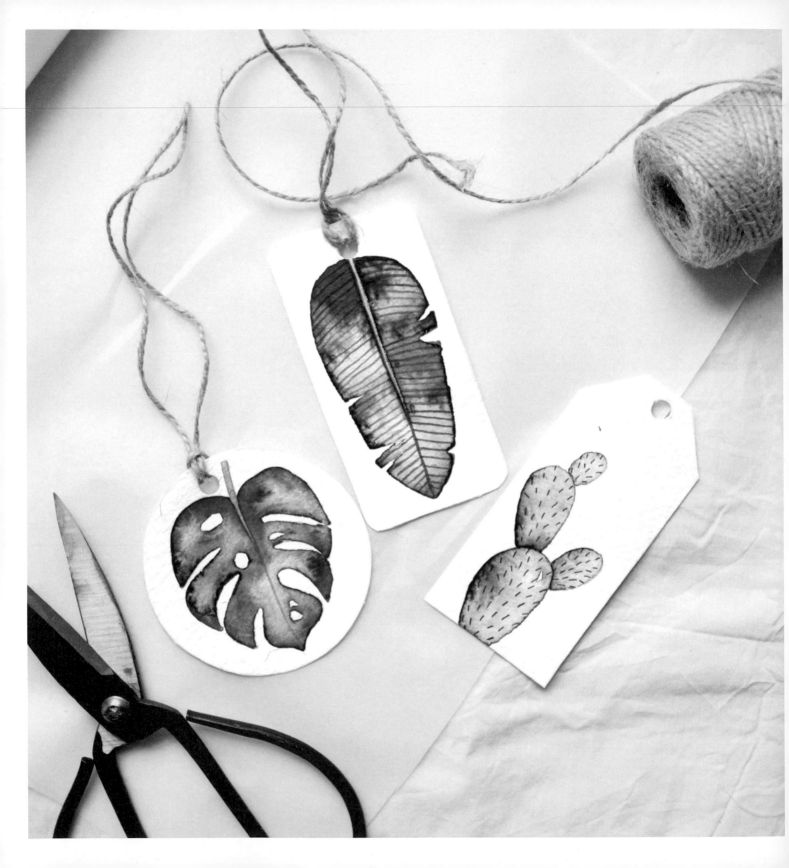

Banana leaf

1. Draw a suitable rectangular tag with a pencil and ruler or set square. Use rounded corners or bevel edges if preferred. My tags measure 3½ x 1¾in (9 x 4.5cm).

2. Sketch the banana leaf, giving it an elongated oval shape that is pointed at the top. Remember to draw in a few randomly distributed slits on the left and right edges, as well as the stem in the middle. The elongated form of the banana leaf should fit neatly into the selected tag format.

3. Mix an appropriate shade of green, using a little paint and a lot of water, and color in the surface of the banana leaf. To produce the light patches, dab the paint already applied with a little water. It will then begin to move and spread in different directions. To create the dark areas of the leaf, mix up a shade with a little water and a lot of paint and dab it onto the relevant areas. Watch how the colors move and interact.

4. When the paint has dried completely you can carefully paint in the darker stem and the lines on the banana leaf using a fine round brush.

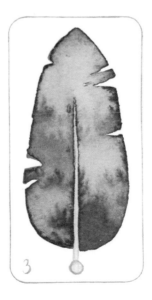

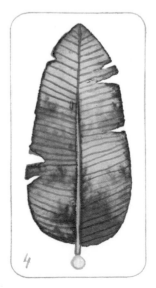

Tip:
The right angles on the gift tags turn out best if you use a set square.

Cactus

1. Be creative and think about other shapes that might work for a gift tag. Then draw the outline using a pencil and ruler or set square.

2. As the cactus should tower upwards, I decided on an oblong format for my tag so that there would be enough height for the cactus.

3. Start by sketching the outlines of the cactus, dividing it into sections.

4. Now color in the sections that are not in contact with one another using an appropriate shade of green. Play with the water and the paint by dabbing deep green tones in some places and working with more water elsewhere. When you are pleased with the results, leave to dry.

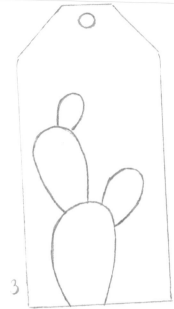

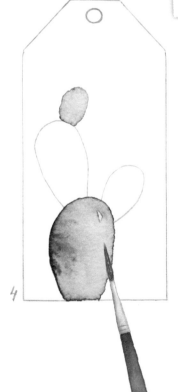

Tip:
These botanical tags can be reused to make fantastic and unique little bookmarks.

5 Repeat the process described in step 4 for the sections that have not yet been colored.

6 When everything is dry you can draw regularly spaced spines around the cactus with a black fineliner pen.

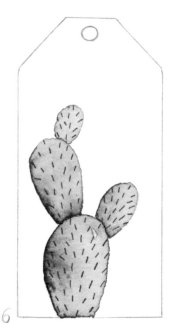

5

6

See pages 78-79 for more lovely plant motifs

Tip:
You might already have another gift tag at home which you can use as a pattern or stencil for your project.

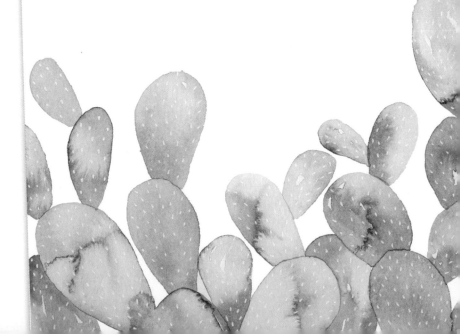

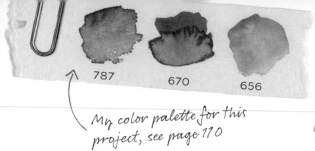

787 670 656

My color palette for this project, see page 110

Party
Panda

Could there be a nicer surprise on your birthday than a homemade card with a personal message on the back? The pleasure produced by little gestures like this, into which so much love and effort have gone, is priceless.

YOU WILL NEED:

· pencil
· eraser
· round brushes, nos. 5/0 and 3
· watercolor postcard, 250g/m²,
 size 6 x 4in (15 x 10.5cm)
· watercolors, see palette
· fineliner pen, black
· cloth
· glass water container

1 For this project you need to sketch the panda in the middle of the paper. Make sure that the distance to the edge of the postcard is roughly the same on all sides as this will make the whole picture more balanced. Start by sketching the oval body of the panda with a thin pencil line, then add the legs, head, ears, and face.

2 Think of a little detail to add that is appropriate to the purpose of the card. I opted for a party hat for a birthday. If this is right for your card, keep it simple, drawing a small triangle onto the panda's head.

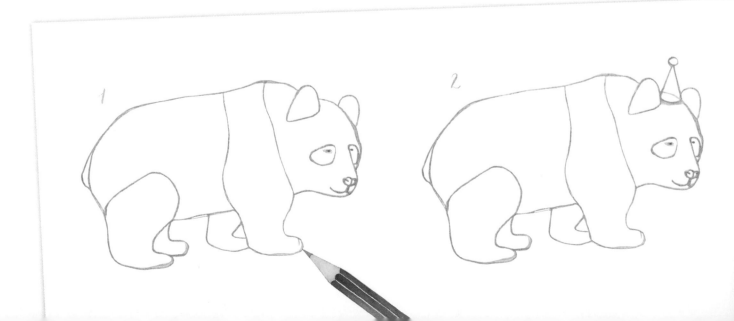

Tip:
Reduce what you see in your mind's eye to simple lines. Forget about the details. This will make it easier for you to transfer the design you are looking for to the paper.

3 Now, with a round brush, start to mix a black tone for the dark fur using Payne's Gray and Madder Brown. The color should be fairly concentrated. Apply the paint to the dark areas around the eyes, the ears, and the two legs nearest to you. Then, preferably while the paint is still wet, dip your brush lightly into more water and dab it onto the painted areas. This will produce the color gradations typical of watercolors.

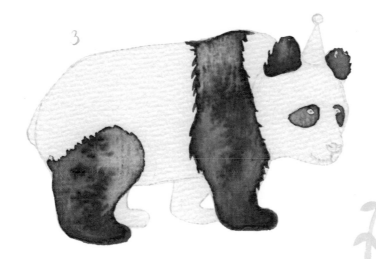

Tip:
Paint slightly over the pencilled sketch lines. This will make the fur appear shaggy and more natural around the edges.

4 When the paint is dry you can color in the legs on the other side of the panda, and add the remaining lines of the panda's body with a transparent gray.

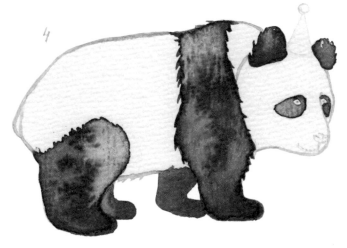

5 Now you can add color to the hat, if using. Start with the triangle, filling it completely with color. When it's dry you can add a pattern and a bobble. Finally, paint some colored confetti on the floor to make the card even more cheerful.

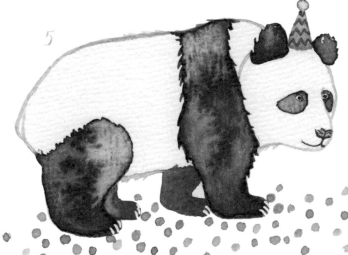

Tip:
If you want to paint a pattern directly onto a base coat of paint, you need to ensure that the color of the pattern is darker or deeper than the base layer itself. This will make the pattern stand out.

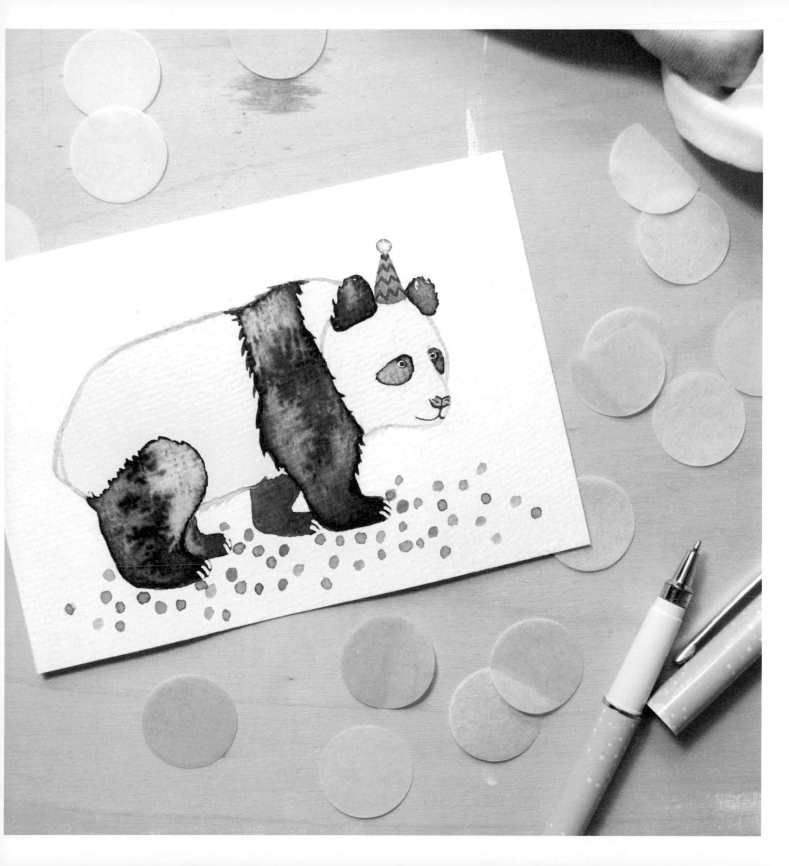

Dachshund
Bookmark

I'm a great fan of literature, and I love giving books to my friends and family as presents. And so that it's not just a gift that you can buy at any old bookshop, I had the idea of jazzing up each one with a personal, unique bookmark. This delightful dachshund wearing a jumper will be the next one.

YOU WILL NEED:

· pencil
· ruler or set square
· eraser
· round brushes, nos. 0 and 3
· watercolor paper, matt, 300g/m², size at least 2 x 6in (5 x 15cm)
· watercolors, see palette
· fineliner pen, black
· Uni-Ball Signo pen, white
· cloth
· glass water container

1. Draw a rectangular bookmark 2 x 6in (5 x 15cm) with a set square and pencil.

2. Now sketch the elongated body of the dachshund, with its pointed nose and its floppy ears, in the middle of the bookmark shape you have drawn. I have used artistic license here to make the dachshund even longer to fit the format better.

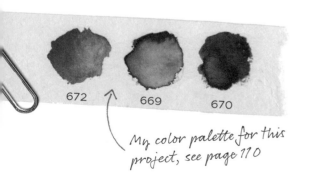

672 669 670

My color palette for this project, see page 110

3 Dress the dachshund in a neat little pullover by adding a few lines.

4 Paint the base layer of the fur with a suitable brown shade. While this is still wet, you can either dab on dark, intense brown shades or add a little water with your brush in the relevant places, nudging the color to the parts where you want to create shadows.

5 When the paint is dry, color in the ears with a darker brown. Don't forget the legs that are still white.

Tip:

The dachshund will also look really cute if you don't use the washing technique, but work instead with a flat application of color.

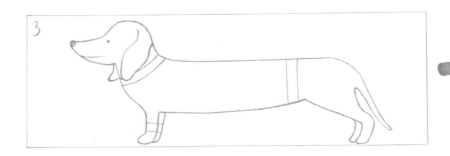

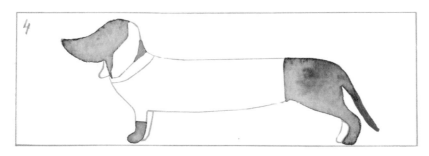

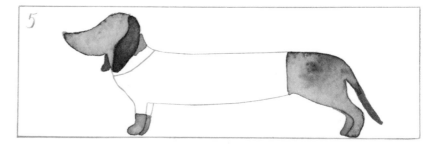

6 You can now paint the red pullover. Follow the directions as for step 4.

7 When the paint is dry, paint the white spots on the jumper with a steady hand. Draw in the lines on the collar and at the lower end, either with white paint or a pen such as a Uni-Ball Signo. You can use a black fineliner pen to add the facial details.

8 Cut the bookmark to size and a new, unique reading companion is finished – you may decide to keep it for yourself!

Tip:

Always pay attention to the consistency of the paint you are using and the moistness of the paper. They may be crucial to the end result.

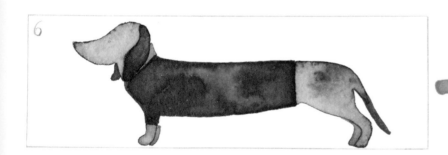

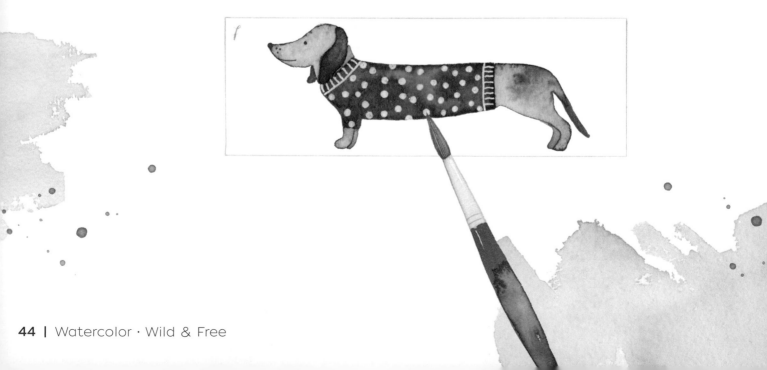

wiesen werden müssen. Kaum war ich mir des...
...ar geworden ... erkannte ich, in welcher Verlegen-
...he ich mein ...und befunden haben mußte, und
ich w... ihm fü... seine Liebenswürdigkeit, mein Ge-
dicht, ... ach wohl erst nach einigem Zögern,
abzudrü... von Herzen dankbar, ja, ich fühlte
m... ... ig bedrückt. Ich rechnete damit,
daß nun ein oder zwei Mitglieder des Jäger-Clubs
empört bei mir protestieren würden, allein, diese
Angst war unbegründet, und auch noch viel später zu
kam mir nicht eine einzige solche Reaktion zu
Gesicht. Mag es ein Glück oder Unglück sein, ich
wurde von den Jägern Japans mit stummer Ver-
achtung bedacht, aber vielleicht komme ich der
...lichkeit am nächsten, wenn ich annehme,
...icht einer von ihnen mein Gedicht ge-
...nate vergangen, und ich
...he vergessen, da
...ir völlig un-
...einen

...in dies...
offensichtlich
...chlagworten ›Die ... ›Gesunde
Sport... ...eist‹, ...n Widerspruch
...ersehbare... ... mein Gedicht
...er Seite, w... ...mer einen ganz
...nalb der Nummer war von
...zu bilden w... ... von
...ederlass... ...ich in mein...
... ...um A...
... betraf gleichwohl das
...te, so wie ich es intuitiv
glaubte. Ich brauchte mich
zu schämen, ich empfand
Ware es in einer anderen
hätte niemand etwas dagegen...
diese hier war das Organ des ja...
...der es sich zur Aufgabe gemach... un...
...nen außerordentlich gesunden un...
zu propagieren. In einer solchen
Auffassung vom Jagen gera-
... entschieden zurückge-
übertr...

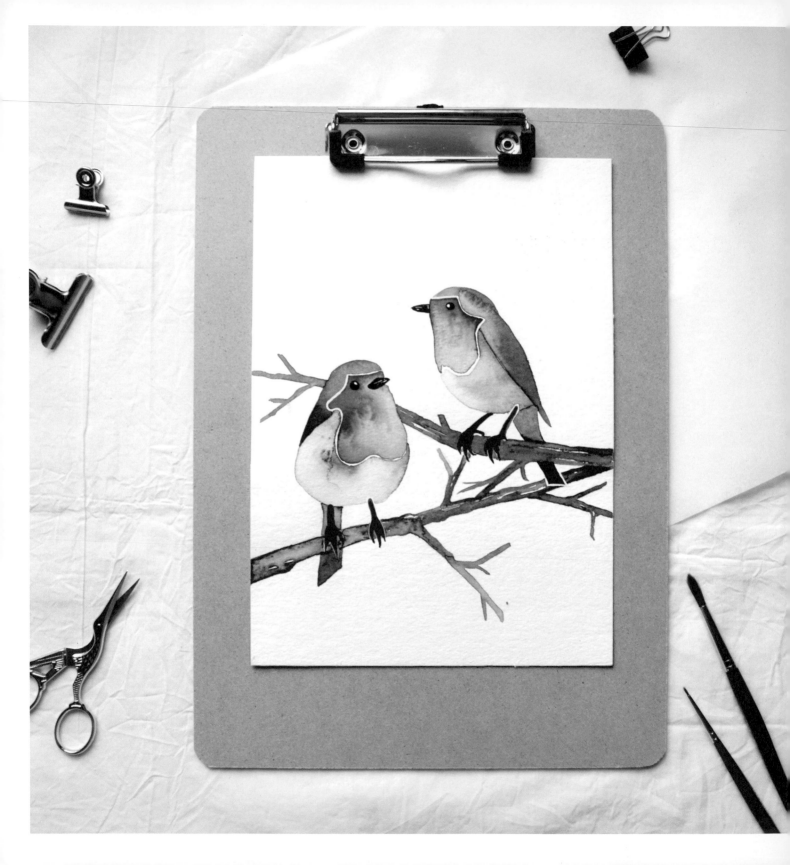

Autumnal
Robins

Who doesn't long to simply fly away – all on your own and as free as a little bird? Create a charming poster with these two robins to give you a sense of freedom on your wall.

YOU WILL NEED:

· pencils
· ruler
· eraser
· round brushes, nos. 5/0 or 0 and 3
· watercolor paper, matt, 300g/m²,
 size 9½ x 6¾in (24 x 17cm)
· watercolors, see palette
· cloth
· glass water container

1 The two robins will fill around half the paper. To be certain of creating a balanced composition, draw some lines to help guide you beforehand. This will make it easier for you to position the birds. Draw two horizontal lines with a pencil to divide the page roughly into thirds. This will give you an idea of the available space for your illustration. Mark the middle of the picture with a vertical line.

Tip:

I see the bodies of the two birds as slightly oval in shape. This association might help you when you sketch the two robins.

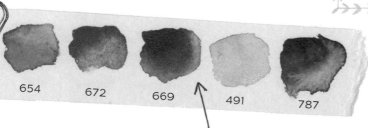

654 672 669 491 787

My color palette for this project, see page 110

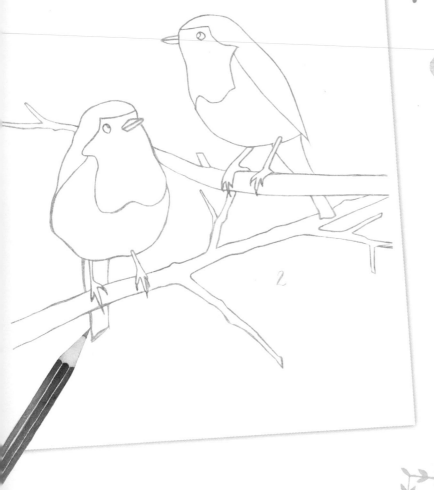

2 Sketch the two robins in simplified lines with a pencil, placing them slightly off center at either side of the vertical line, with one slightly higher than the other to increase the dynamic of the image. The robin's bodies can easily be divided into three color sections – brown, red and blue – which will help later when you add the color. Draw these sections into your sketch. Finally draw in two bare branches on which the two birds are to perch (see tip below), protruding into the image from left and right.

Tip:

It's up to you whether you begin by drawing the birds or if you prefer to start with the branches and add the birds afterwards, adjusting their position accordingly. Just decide which way you work best.

3 Now you can start to mix and apply the first color. Use Gold Brown and Mahogany Brown for the red breast, adding sufficient water. Clean your brush and absorb a little water with it for the color wash gradations, then dab the appropriate points on the color already applied. Now you can simply wait and see how the color moves over the paper or even help it along by gently pushing the water in the preferred direction with the brush. The legs of the two birds can also be colored in with a dark brown at this stage.

4 Using the technique described in step 3, now paint in the lower part of each body with a slightly transparent, well-diluted blue. Leave a clear, narrow gap between the red and blue sections. This will keep the sections separate and prevent the colors from running into each other.

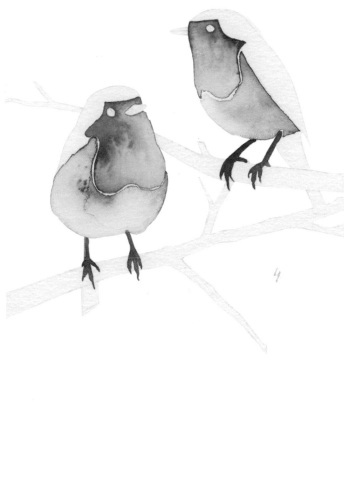

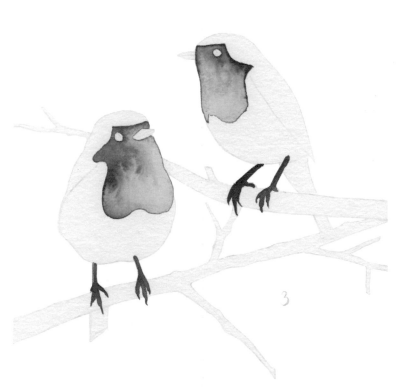

5 Now only the third color section of the robin remains to be painted: the top of the head, the back and the tail. Color these as described in steps 3 and 4, using a dark, moderately diluted brown such as Vandyke Brown. When the red section of the robins is dry, you can paint in the eyes and beaks with a thin brush, for example a size 0, using a very concentrated Payne's Gray that has been diluted using only a very small amount of water. This produces a deep, almost black tone.

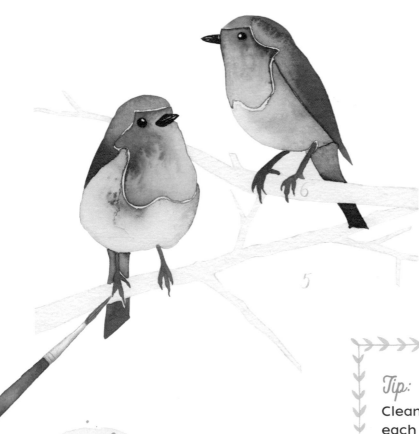

Tip:
Clean your brush properly before each new shade to avoid unwanted color contamination.

See page 88 for more delightful bird designs

6 Finally, paint the branches using a moderately diluted brown. Don't fill the spaces completely, but leave some areas white. These will give the image dimension and will act as light reflectors, making the picture more lifelike.

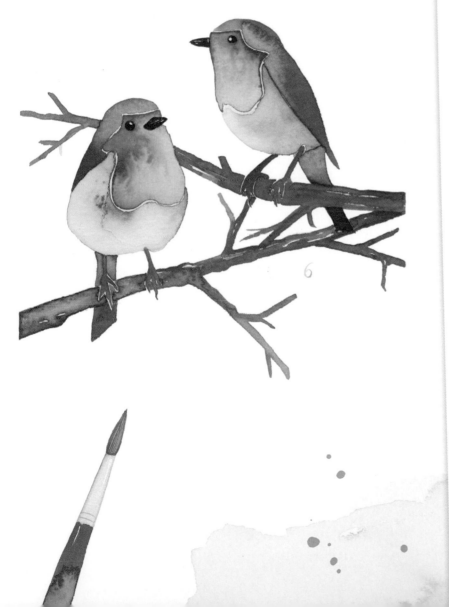

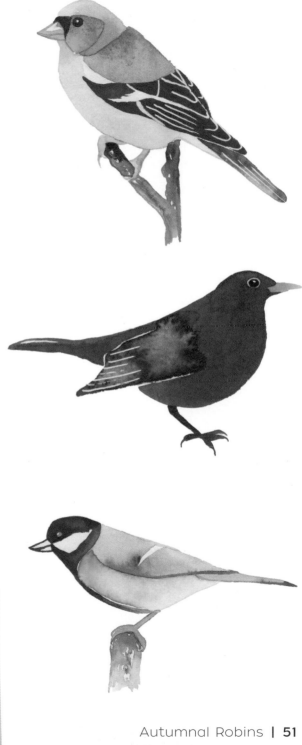

Cactus
Poster

Cacti are popular houseplants – not just because they have an extremely strong urge for survival and grow well even for the less green-fingered among us. They also remind us of sunny days and the exotic locations where they grow freely in the wild. Anyone can have some of these prickly friends on their own windowsill. Or, even simpler still, hang one on your wall with this green project.

YOU WILL NEED:

· pencil
· eraser
· round brushes, no. 5/0 or 0 and 3
· watercolor paper, matt, 300g/m²,
 size 9½ x 6¾in (24 x 17cm)
· watercolors, see palette
· cloth
· glass water container

1. Start by drawing two elongated, cucumber-shaped cacti, pointing up towards the top of the picture. Try to avoid details, drawing the outer lines and then the individual sections of each cactus.

2. You will be coloring in alternate sections of the cacti so that you are not working on parts directly next to each another. This will stop the colors running together, and you will get clearly defined grooves. Mix up an appropriate shade of green for this, diluting it with varying quantities of water as required in the next step.

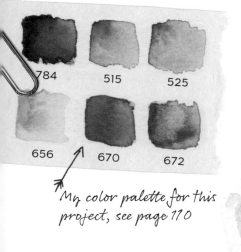

784 515 525

656 670 672

My color palette for this project, see page 110

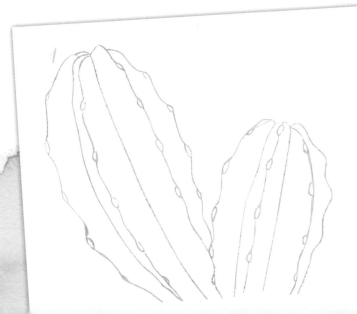

4 When the paint on these sections of the cactus is completely dry, repeat the process described in step 4 for the remaining white sections.

3 Start with a base layer of light green on the left-hand outer section of the first cactus. Then, while the color on the paper is still wet, dab a darker green onto the places that are in shadow on the cactus. Repeat this process from left to right with all the other sections of the cacti that are not adjacent to one another.

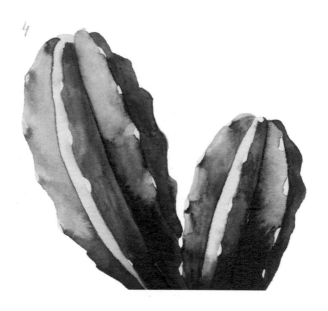

4

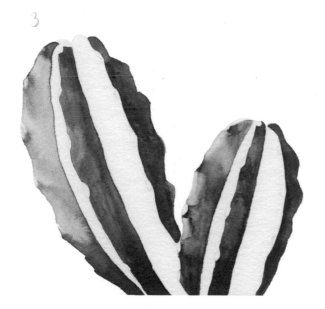

3

5 Once these green sections have dried, paint the areoles – the elongated, oval bumps from which the spines grow – in yellow and brown tones. Leave everything to dry fully.

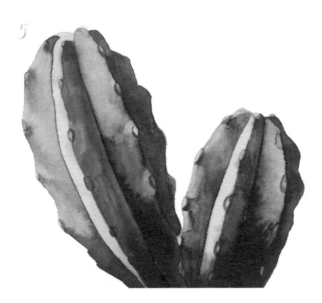

6 Finally, paint the spines protruding from the areoles in white, brown, yellow, and dark green. A fine brush is best for this.

Tip:

When painting the spines, make sure that the paint is not too watery. Otherwise, it may run unexpectedly on the paper or drip from the brush.

Tip:

The spines on the dark sections of the cactus should have an intense yellow or white tone, mixed with only a little water, so that they stand out from the dark background. The opposite applies to the spines that are visible on the light-colored sections. It's best to use dark colors for these.

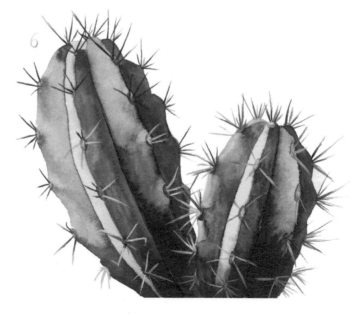

Cute Animal
Gift Tags

These animal gift tags will add another unique touch to your lovingly wrapped presents for family and friends. And their new owners can re-use them as bookmarks or wall decorations.

YOU WILL NEED:

· pencil
· eraser
· round brushes, nos. 0 and 3
· watercolor paper, genuine mold-made, matt, 300 g/m², smallish scraps
· watercolors, see palette
· fineliner pen, black
· cloth
· glass water container

1 Draw three equally sized circles for your gift tags using a drinking glass to draw around.

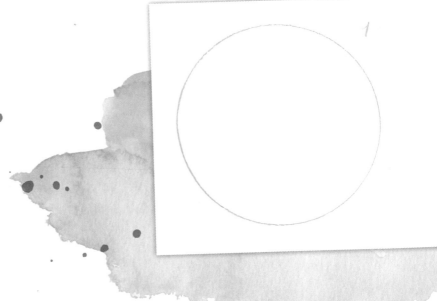

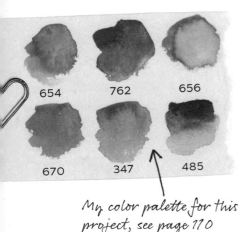

654 762 656

670 347 485

My color palette for this project, see page 110

Tip:

After drying, cut out the gift tags with scissors and use a hole punch for the holes to thread a pretty cord or ribbon through.

Cat

2 Sketch a large cat's head in the middle of the circle. Add a spotted party hat between the ears.

3 Now paint a base layer of an appropriate brown shade over the head for the cat's fur, but leave the area around the nose white. The paint should be completely dry before the next step.

4 Paint the hat in blue, without coloring the spots. Add the inner part of the ears and the nose in a light, transparent pink and add a light green stroke to the eyes.

5 Finally, give the cat irregular tiger stripes, painting them on with a brown that is quite a bit darker than that used for the fur. Draw the outline of the eyes with a deep, dark brown, and color in the spots on the hat with a deep yellow, mixed using a lot of paint and not much water.

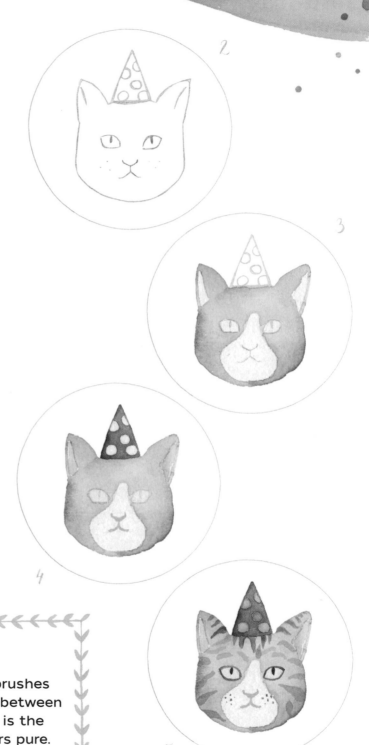

Tip:
Don't forget to clean the brushes carefully with fresh water between each change of color. This is the only way to keep the colors pure.

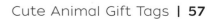

Cow

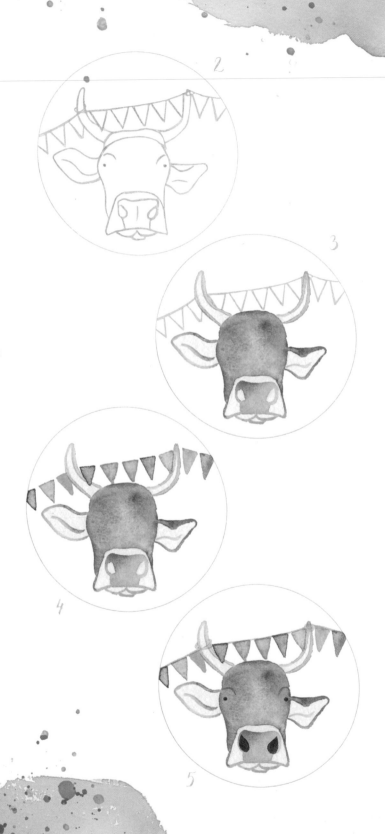

2 Sketch a cow's head in simple lines on the next round gift tag. The horns are ideally suited for hanging something around – for my gift tag I've chosen some bunting.

3 Mix up an appropriate brown color and use it to color in the head and to draw in simple lines for the horns, ears, and mouth, using a fine round brush.

4 Paint the individual blue, pink, and yellow flags, one color after another.

5 Finally, draw in the remaining details such as the eyes and nostrils with a black fineliner pen or with black paint. Join the individual flags together with a gray line to complete the bunting.

Tip:
The overall effect will be more consistent if colors are repeated in your picture.

Koala

2 For the koala, draw a round head and two oval ears in the middle of the final gift tag outline. Add the distinctive nose, the mouth and understated eyes.

3 Mix up an appropriate gray with a lot of water and use it to paint in the head and ears. Leave the nose and mouth unpainted.

4 When the paint is dry, add the ears and the area around the mouth using a soft pink color made with a lot of water.

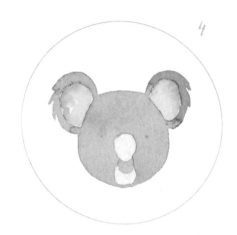

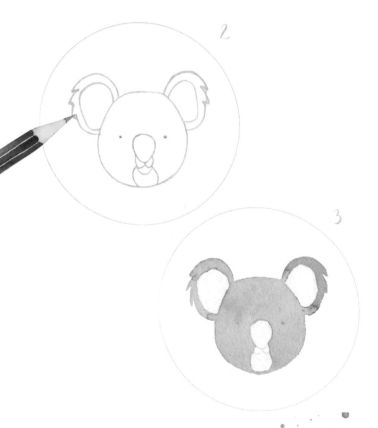

Tip:
Work in layers and wait until the previous paints are completely dry to prevent the different colors from mixing.

5 Finally color the nose and mouth with a deep, dark blue tone. You can draw in the eyes with a thin fineliner pen. Paint cheerful confetti in the background, using small spots of soft pink.

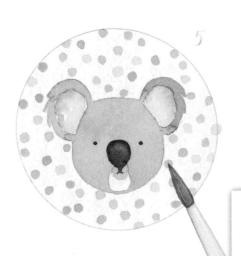

Tip:

If you don't have any gray in your box you can mix it using the primary colors: yellow, red and blue. Mixing an equal amount of these colors will produce a matt gray.

See pages 80-85 and 90-93 for more charming animal designs

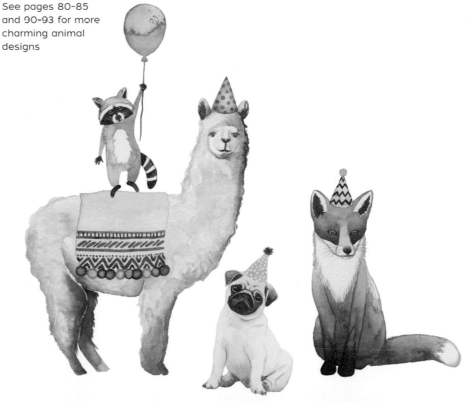

On Safari
· with Elephants

Take yourself on a little safari with brush, paint, and paper, to see two elephants blithely strolling by at a slow pace through the grasslands of the Savannah.

YOU WILL NEED:

- pencil
- eraser
- round brush, no. 3
- flat brush, no. 14
- watercolor paper, real handmade, matt, 300 g/m², size 12½ x 9½in (32 x 24cm)
- watercolors, see palette
- fineliner pen, black
- Uni-Ball Signo pen, white
- cloth
- glass water container

1 Draw a light horizontal guideline right acroos the middle of the paper. Add a vertical line at each side of the paper to help you maintain an equal distance from the edges. Position the two elephants in the lower section of the picture, by sketching their prominent shapes with light pencil marks directly under the horizontal line, as shown below.

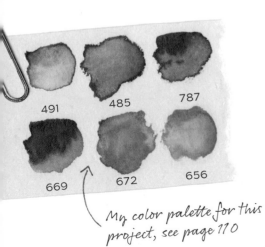

491 485 787

669 672 656

My color palette for this project, see page 110

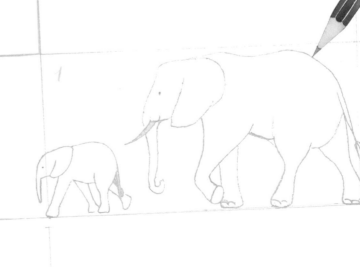

2 Still working below the horizontal line, draw the outline of a range of hills behind the elephants. When you are satisfied with your composition, rub out the guidelines and draw a rough, vertical rectangle with rounded corners around the drawing. This will help hold the individual sections of the picture together from a visual perspective.

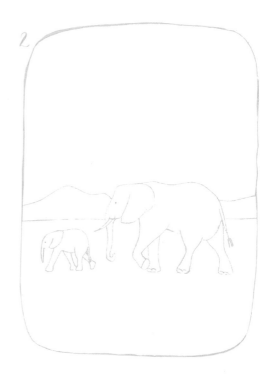

3 Now start on the bright blue sky. A size 14 flat brush is suitable for this extensive area, which takes up around half of the illustration. First paint a narrow dark blue strip at the top and add a lighter blue while it is still wet, so that the two shades merge into one another. The further you go towards the hills, the lighter and more transparent the blue color should become. You can achieve this by diluting the paint with more and more water and gradually drawing it downwards. You can also get a little water on a clean brush and dab it upwards over the applied paint, so that much of the color is pushed upwards.

4 Create a base layer for the Savannah over the entire ground area with a soft ocher shade. Don't be afraid to use a lot of water, as it will make it easier for you to dab darker shades onto the base layer and let the color run over the paper. The color gradations produced should give the impression of natural grasslands.

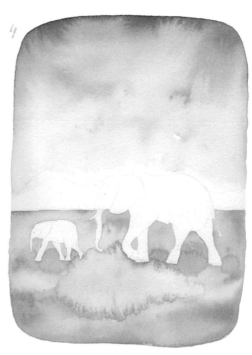

5 Allow the color to dry properly and then paint the hills in a shade of brown. Leave some areas white to reflect the light.

6 Now start to fill in the elephants' bodies with a light gray base and sufficient water. Dab the areas of shadow with a darker color. You can also dab the areas that you want to keep light with a clean, moist brush, if necessary.

7 When it's all dry, draw in the two eyes and the tusk with a black fineliner pen. In order to separate some of the body parts and define them more clearly, you can draw in the relevant lines with a white Uni-Ball Signo pen.

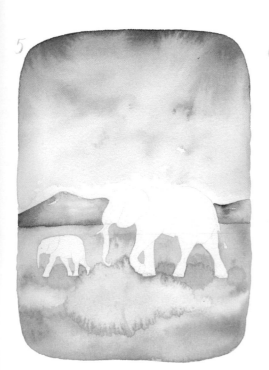
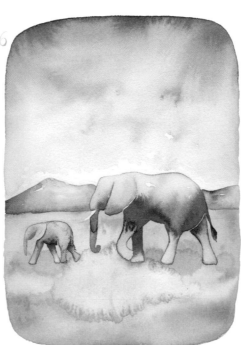
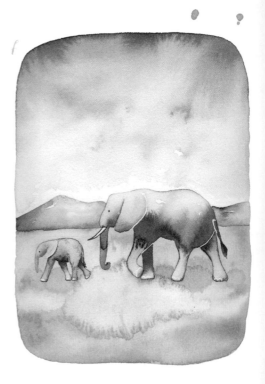

Tip:
if an area intended to be kept light gets too dark, just dab the paint off with a cloth. This enhances the light effect.

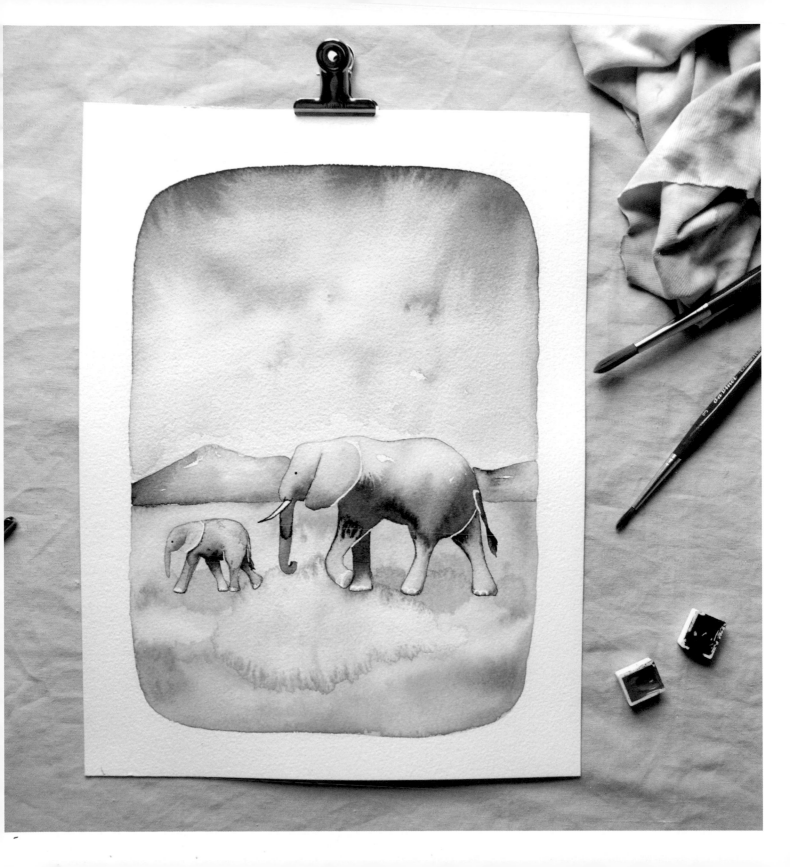

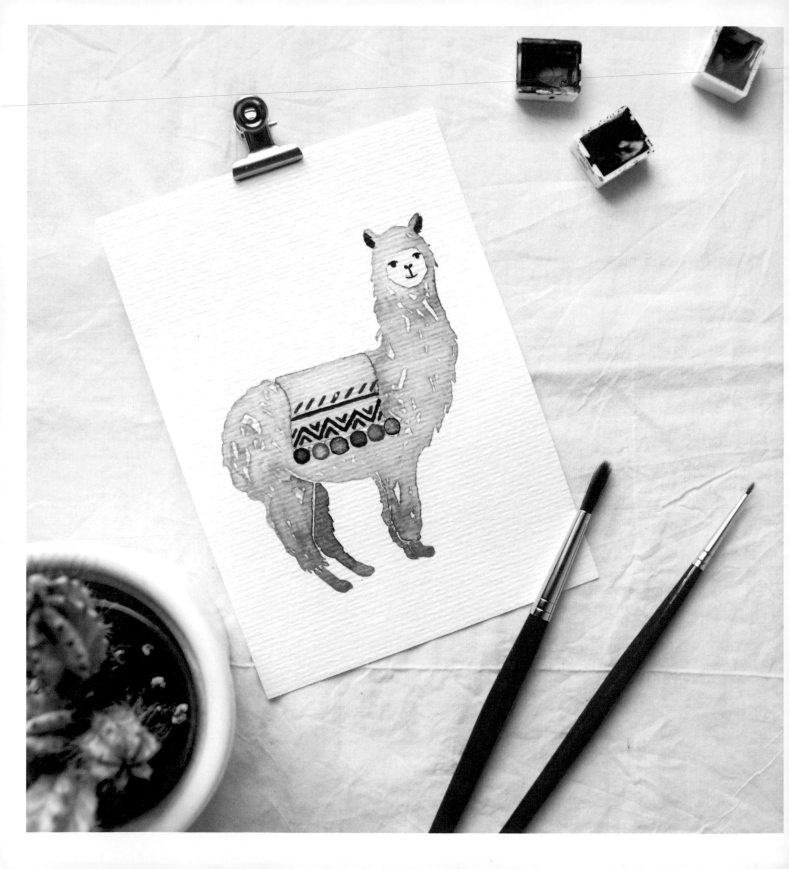

Alpaca
Postcard

Receiving personalized post from your friends and family is wonderful. Tell your loved ones about your adventures or talk about fascinating travels with this alpaca postcard. One thing is certain – an alpaca would definitely make a fantastic traveling companion.

YOU WILL NEED:

· pencil
· eraser
· round brushes, nos. 5/0 and 3
· watercolor postcard paper, 250g/m², size 6 x 4in (15 x 10.5cm)
· watercolors, see palette
· fineliner pen, black
· cloth
· glass water container

656 672 669 670 787

My color palette for this project, see page 110

1 Draw your sketch in the center of the paper as the alpaca is going to be the centerpiece of your postcard. Start with the alpaca's oval-shaped body in the middle of the page and slowly work in the neck, head and legs.

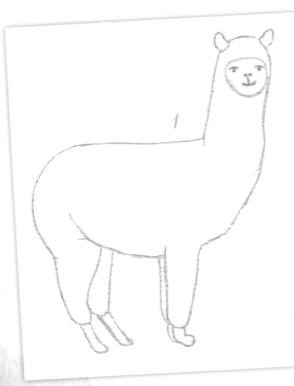

2 When you've finished the body and are happy with it, draw in a rectangular throw over the alpaca's back. For a more dynamic impression, the edges should be swinging slightly in one direction. Draw some geometric patterns over the throw in any way you like, to make it look like a traditional piece of Peruvian handicraft. Finally add some medium-sized bobbles to the lower edge of the throw.

3 Gently rub out the pencil sketch to ensure that the lines don't show through the paint. I used brush size no. 3 and yellow raw ocher and mahogany brown for the fur. Mix the paint with sufficient water so that the individual brush strokes will run into one another to give an impression of the alpaca's shaggy coat. Apply the paint downwards in short curving brush strokes. Add a darker tone to the shadow areas of the alpaca, such as the under belly or in between the legs. This is best done while the fur color is still wet. All this will make the alpaca look more lifelike.

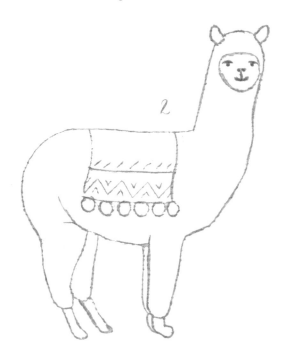

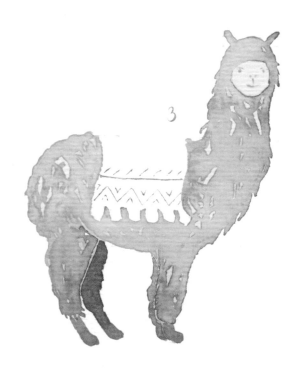

Tip:
Leave small gaps here and there in the fur. This will make the alpaca's coat appear more natural.

4 When the fur is dry, paint a base layer on the throw in a light transparent gray tone. Draw in the lines of the alpaca's face with a thin black fineliner pen.

5 Once the alpaca's throw is dry you can start to paint the patterns with lightly diluted paint. Use a particularly thin brush for this, for example a size 5/0, so that the patterns don't run into each other and are clearly defined. The paint must not be mixed too thinly, otherwise it will run. Finally, color in the bobbles on the throw, alternating various colors such as red, yellow, and blue.

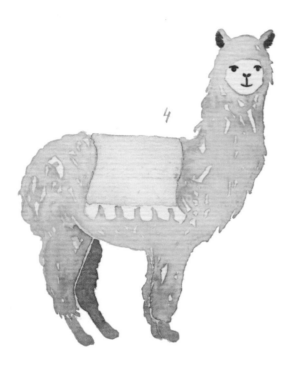

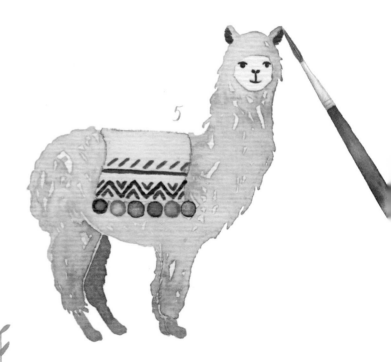

Tip:
If you prefer the fur to be more defined and want the individual brush strokes to stand out more, work with less diluted paint so that the brush strokes are defined separately and do not merge.

Wild Forest
Animals

This wildlife project takes you directly into the
wild woodlands, where rabbit, bear, and fox await you
under a night sky that is sparkling with stars.

YOU WILL NEED:

· pencil
· ruler
· eraser
· round brushes, nos. 0, 3 and 5
· flat brush no. 14
· watercolor paper, matt, 300g/m²,
 size 12½ x 9½in (32 x 24cm)
· watercolors, see palette
· fineliner pen, black
· Uni-Ball Signo pen, white
· cloth
· glass water container

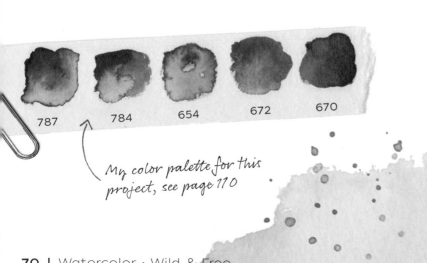

787 784 654 672 670

*My color palette for this
project, see page 110*

1 Draw a bear standing upright in the middle of the
page, using simple lines. He will be the focal point
around which the composition will be structured in
the stages that follow.

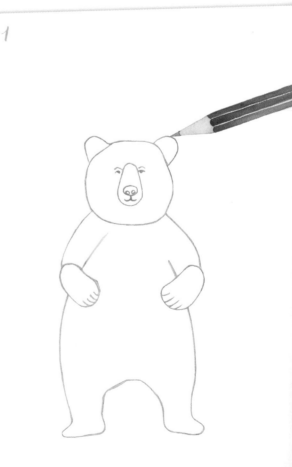

Tip:

Tip:

It can sometimes help to divide the picture into foreground, middle ground, and background from the outset and then add the relevant motifs, in this case bear, rabbit, and fox. Try it out to see what works best for you.

2 Sketch a rabbit at one side of the bear and a fox on the other. The different sizes of the animals create more tension in the picture.

3 Now place three fir trees in the background, with their tops tapering upwards. Add a crescent-shaped moon in the upper left section of the picture.

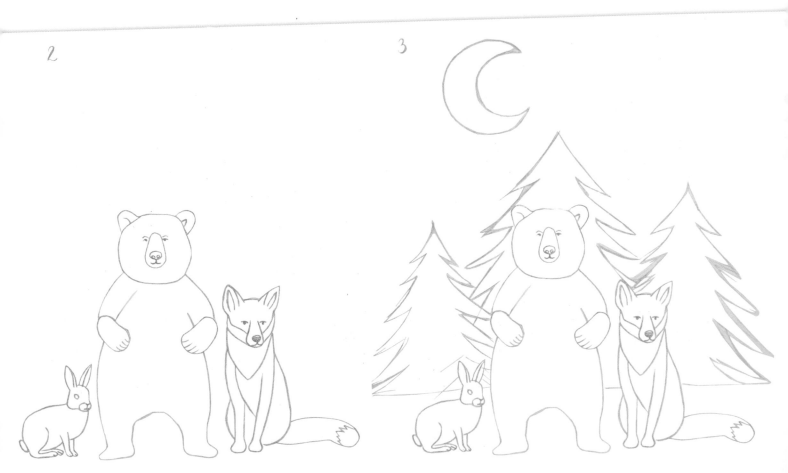

2

3

4 When you are happy with your composition, start to paint in the color. Moisten the paper in the area of the night sky and mix up a dark blue with round brush no. 5. Now dab this on at various points. Allow the paint to run and form patterns by dabbing more water in some areas. Wait and see what happens. Color in the ground in the lower section of the picture using a large flat brush and a suitable dark green color without too much water.

Tip:
Use deep, only slightly diluted paints for the sky and ground, as this is a night-time scene that requires dark shades to create the right effect. You should bear in mind that watercolors always fade slightly as they dry.

5 When the earth and sky are dry you can begin to paint the fir trees in a dark green shade and the moon in a light gray.

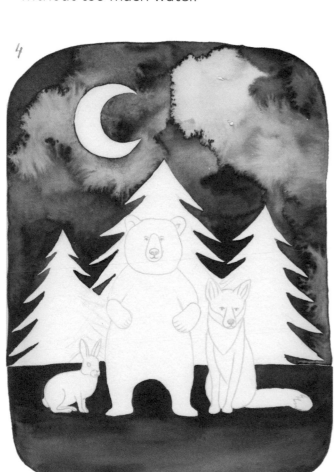

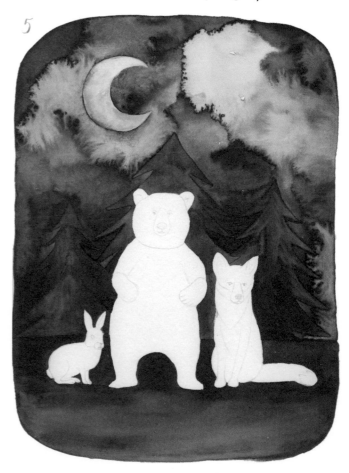

6 Gradually paint in the animals' coats: the rabbit in gray, the bear in dark brown and light brown for the fox as shown.

7 When the sections painted in step 6 are dry, add color to the remaining parts of the fur. Leave the white areas on the animals unpainted.

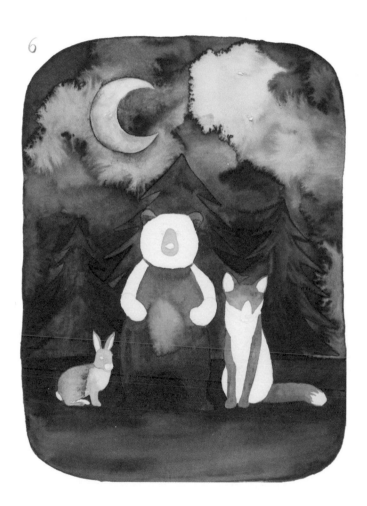

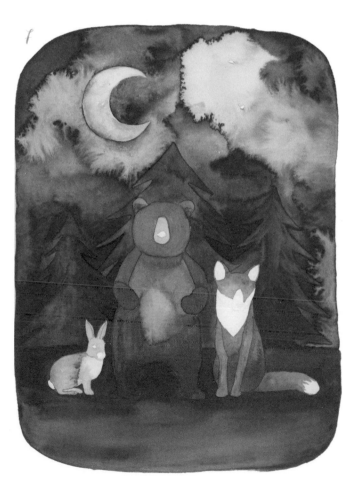

8 At this point you can focus on the details. Draw in the eyes and noses of the individual woodland animals with a black fineliner pen. Add little white points of light in the black eyes with a white Uni-Ball Signo pen and paint the bear's claws with a few simple strokes. Use a dark paint or the black pen to add in the fox's legs and the inner section of the ears and then draw in the tip of the nose with an inconspicuous gray tone using a thin brush.

9 Finally paint in the starry sky with white paint or use the white Uni-Ball Signo pen. Just scatter large and small dots here and there at random all over the sky.

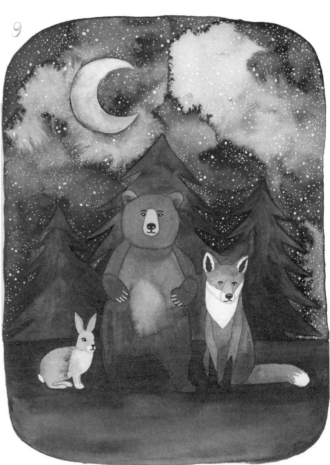

8

9

Tip:
You can use a hairdryer to speed up the drying process. Take care not to hold it too close to your paper, otherwise it may move the color.

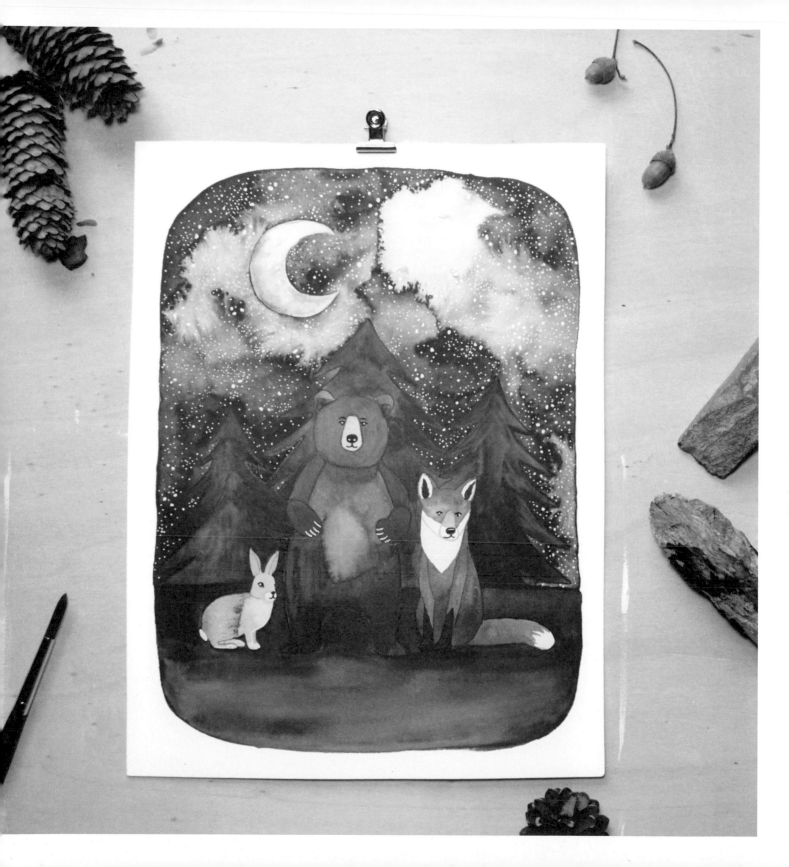

INSPIRATION
Gallery

Just like your handwriting, your individual painting style will develop through regular practice and trying out new things. This is the only way to find out which method of painting suits you best, what you like doing and what you don't, the materials that appeal to you, the brush size that gives you the best results, and the paper that provides the best painting surface for you.

The next chapter offers a creative smorgasbord of different designs that I have put together for you to give you further inspiration in your work. You can play around with them creatively and experiment with other designs in combination with the projects presented here, to create your very own unique works of art, large and small.

Plants

Animals
Cats

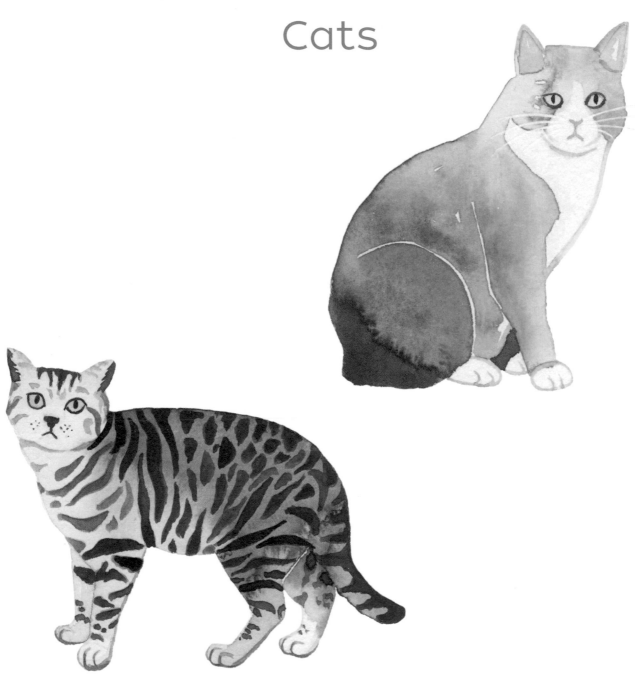

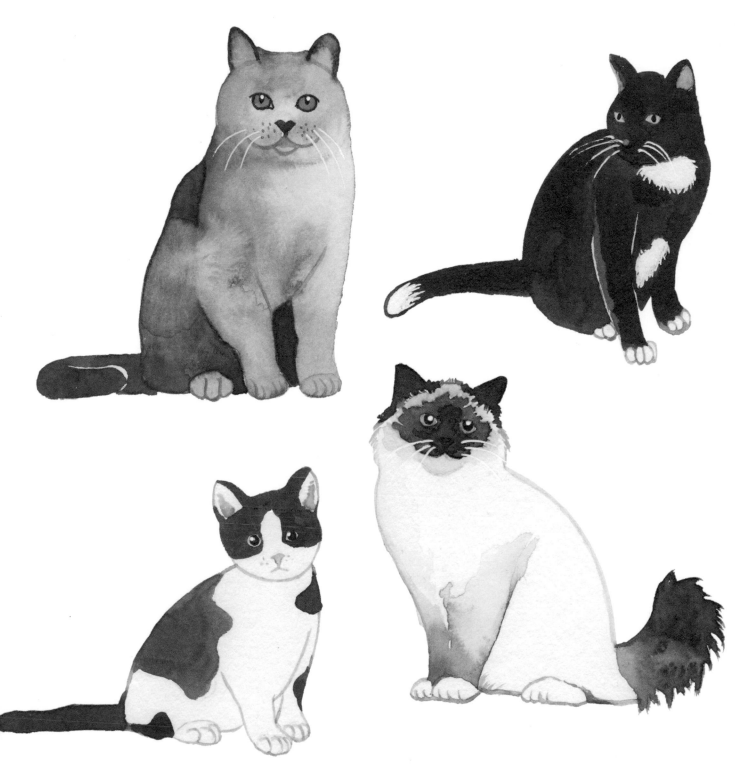

Dogs

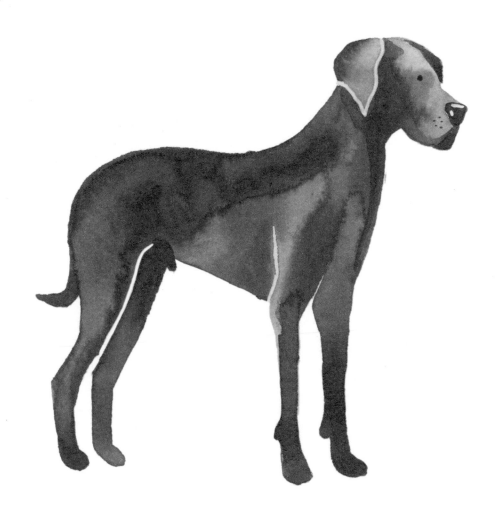

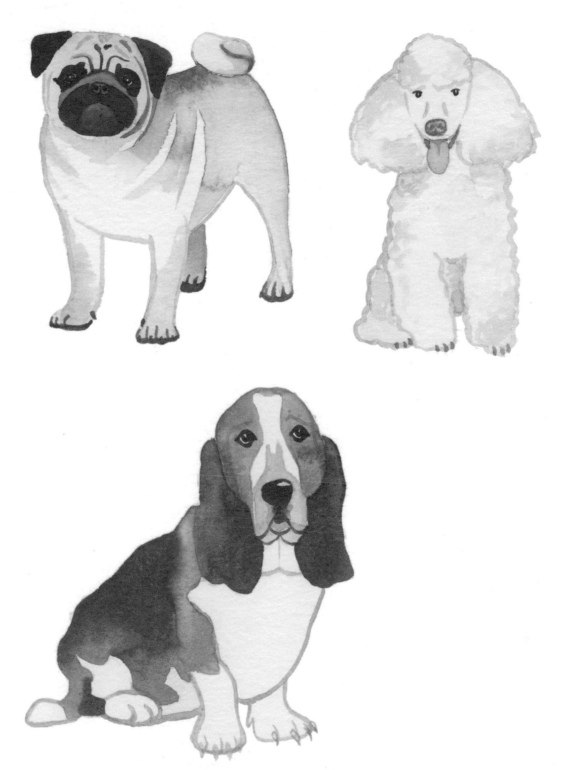

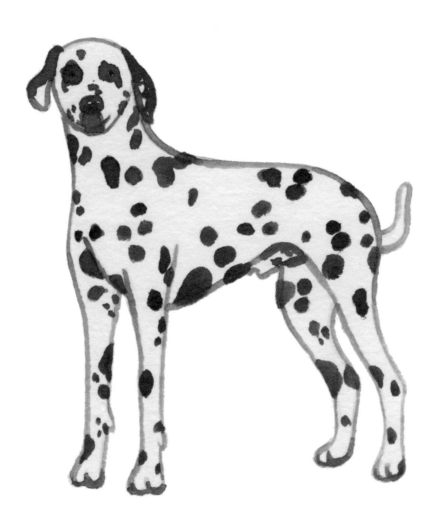

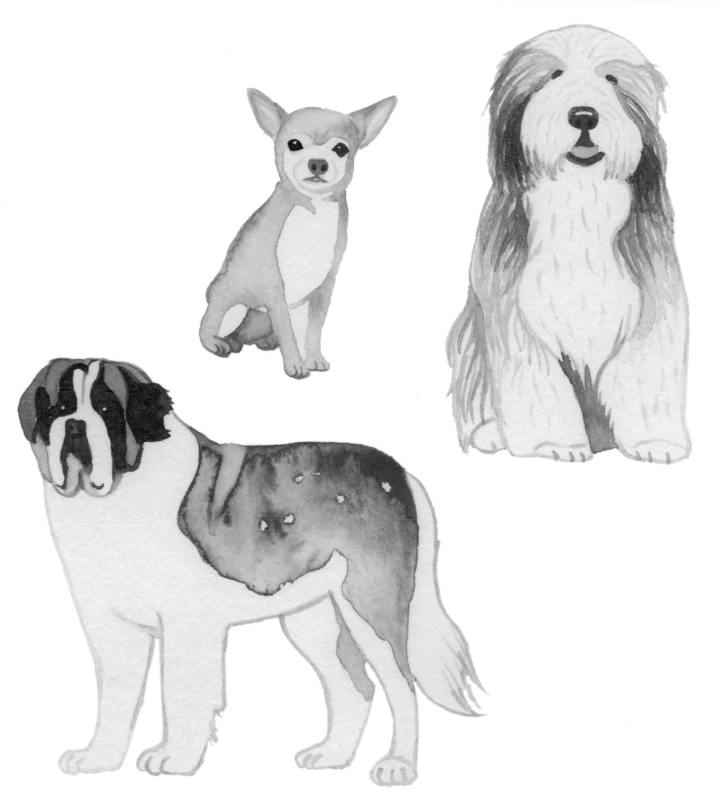

Beetles

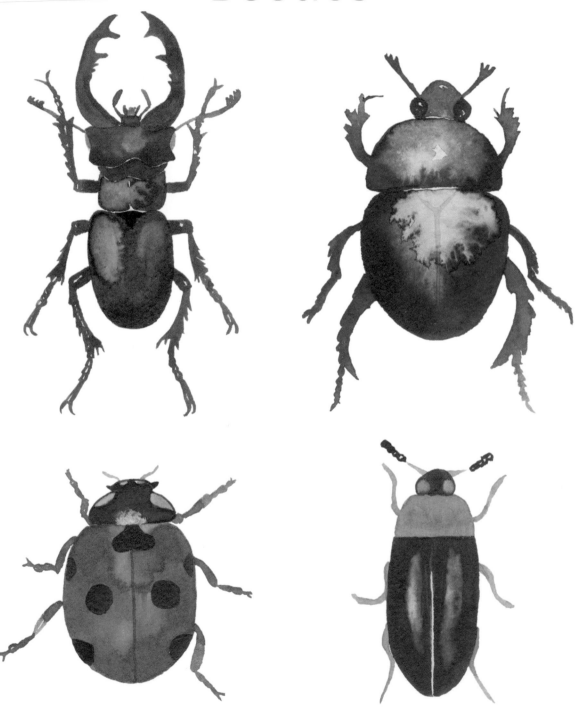

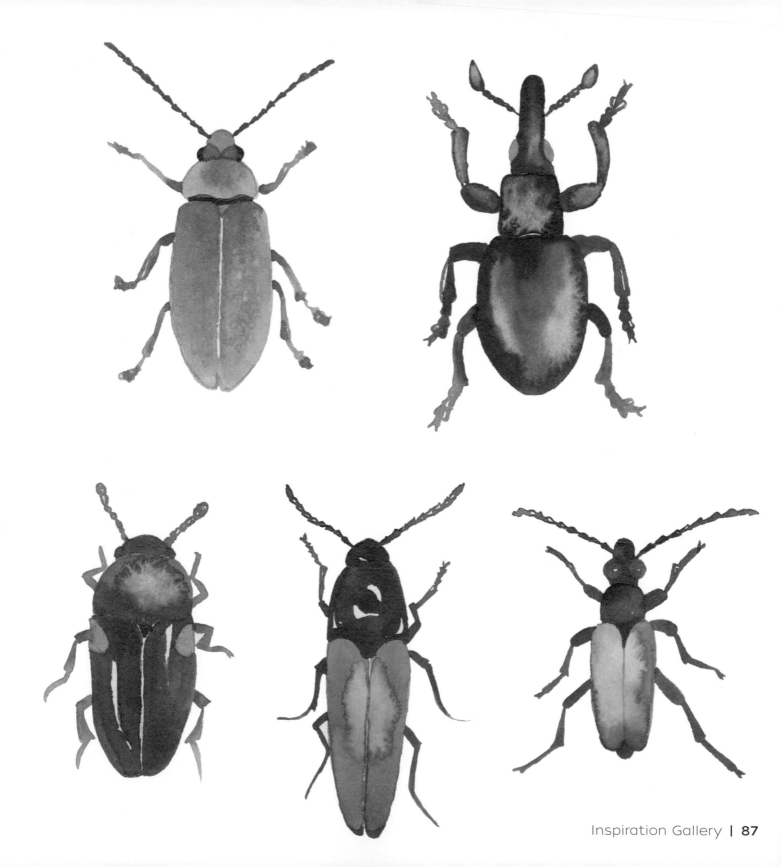

Birds

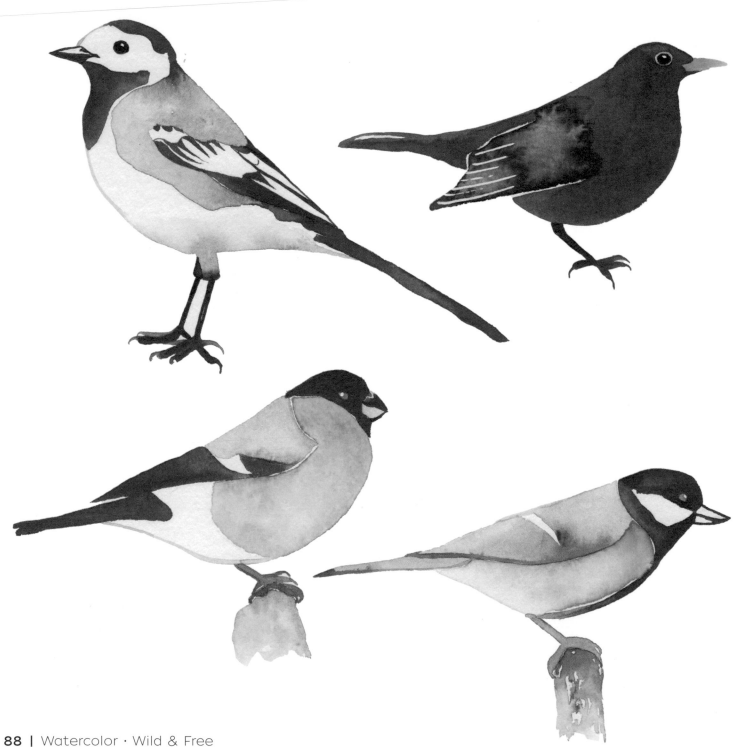

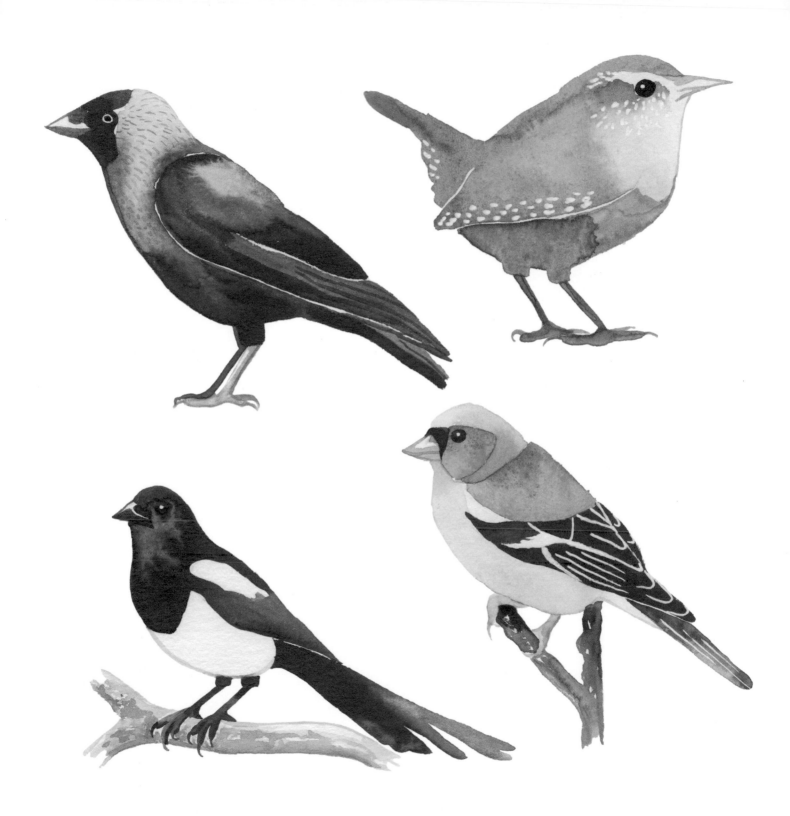

In the Forest

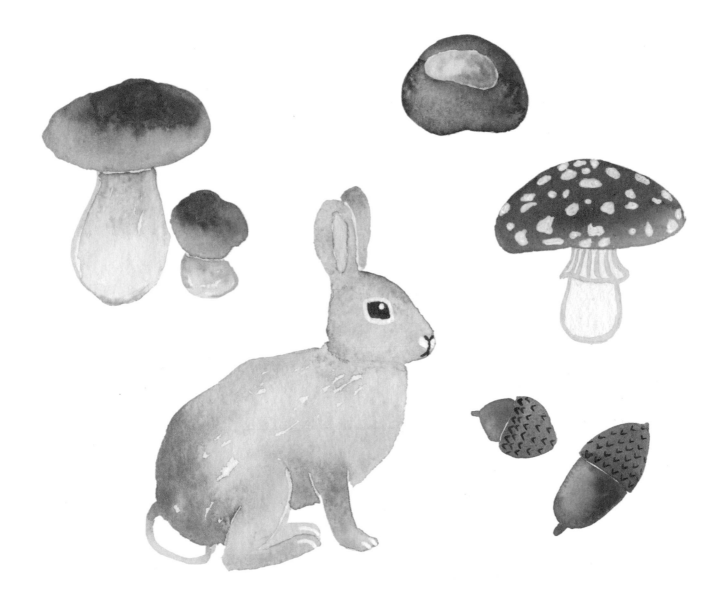

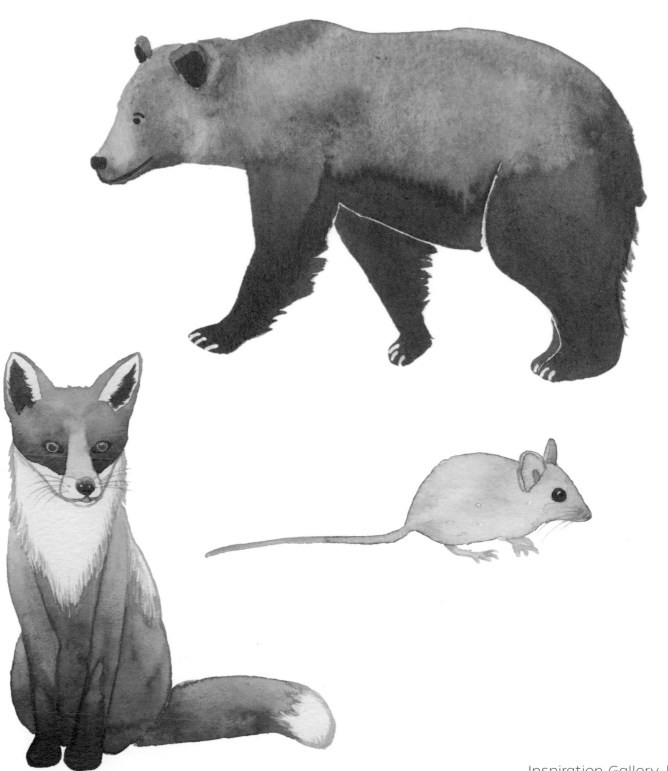

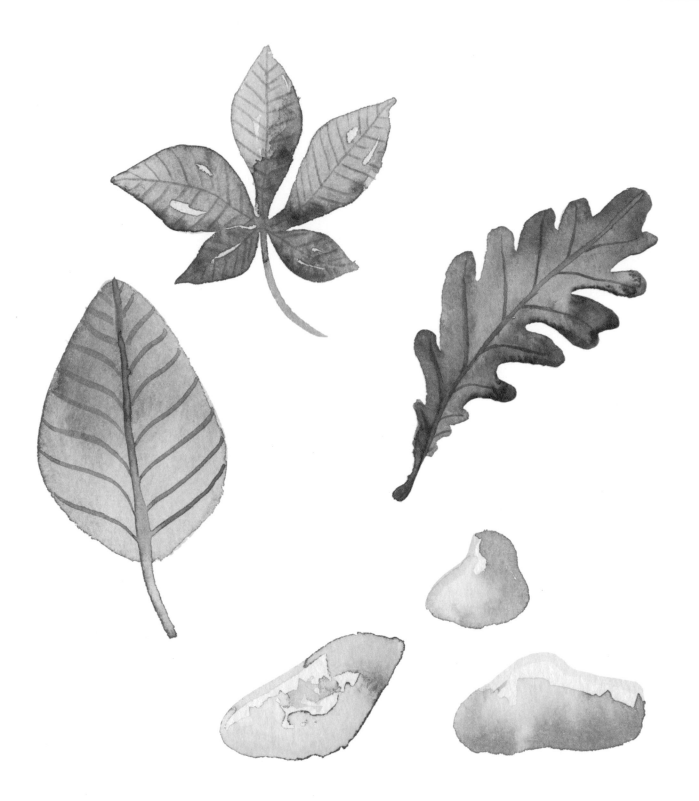

Under the Sea

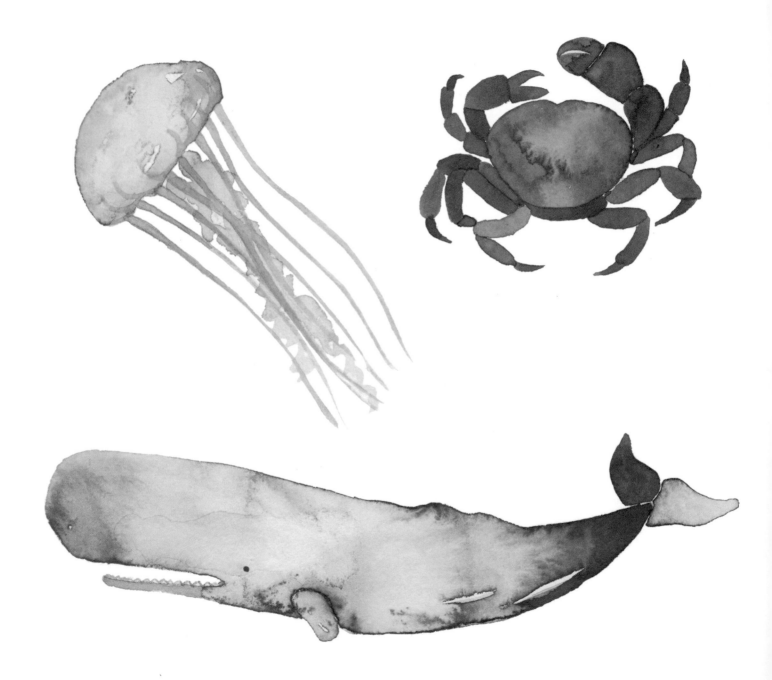

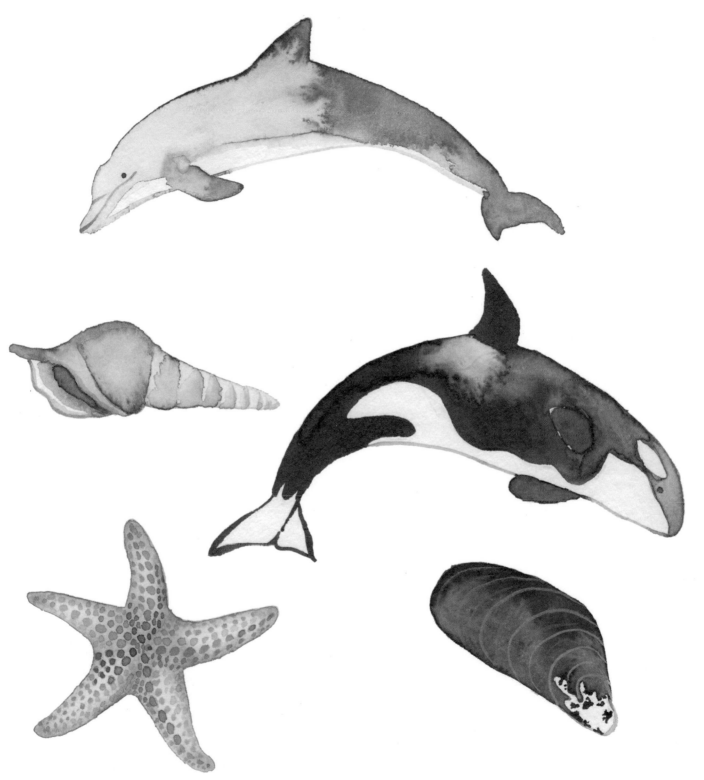

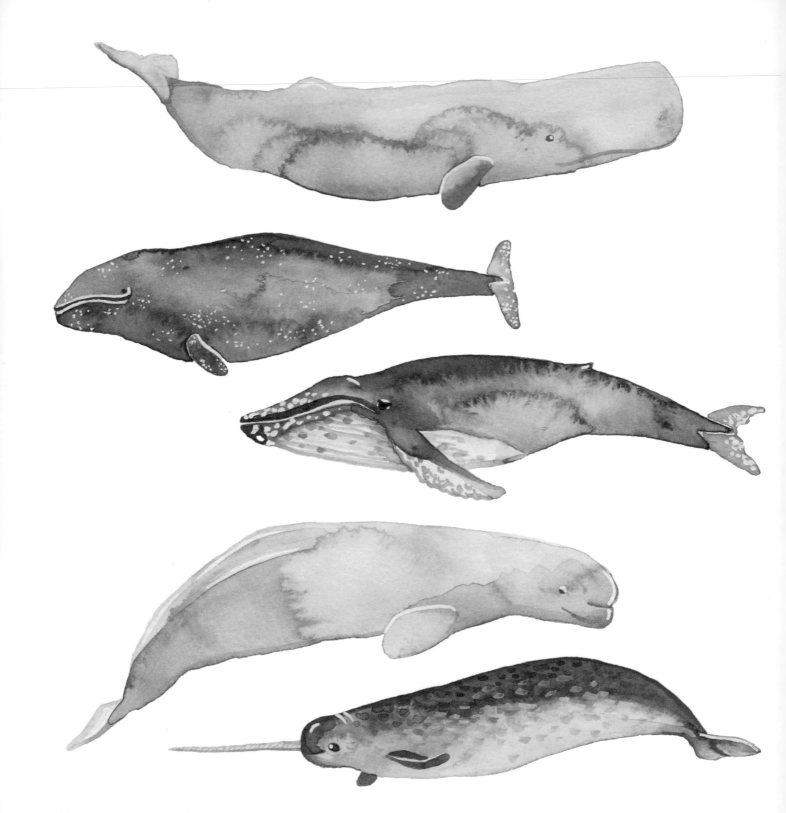

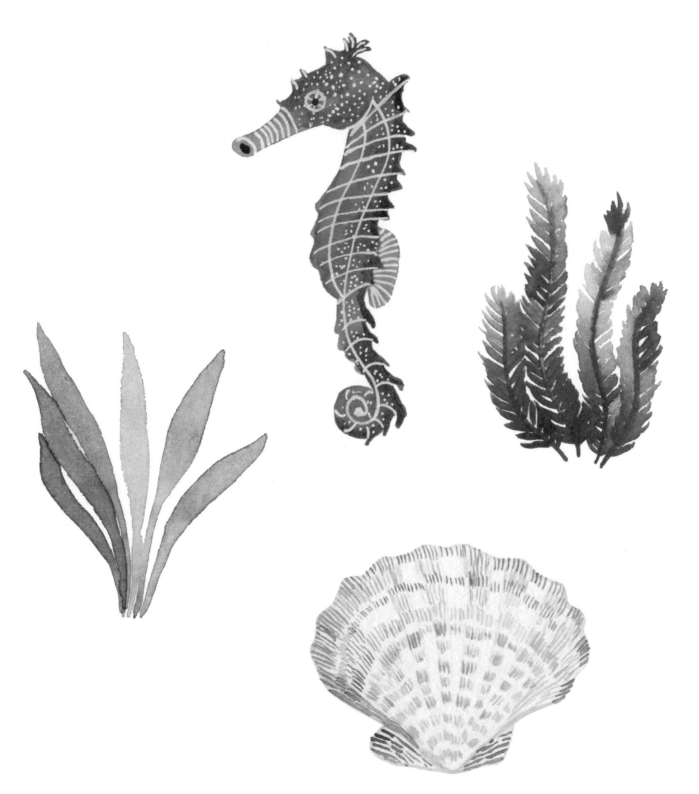

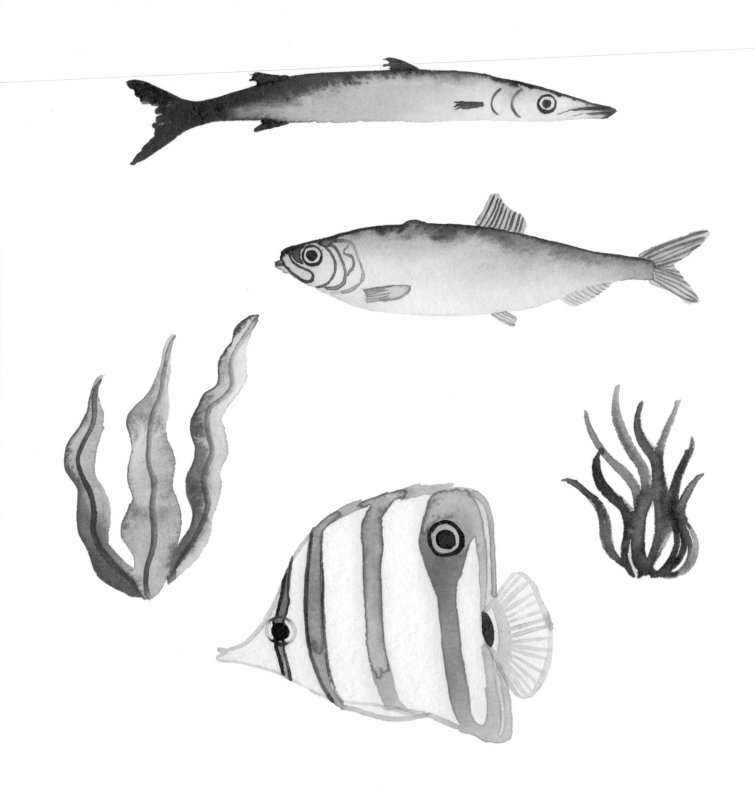

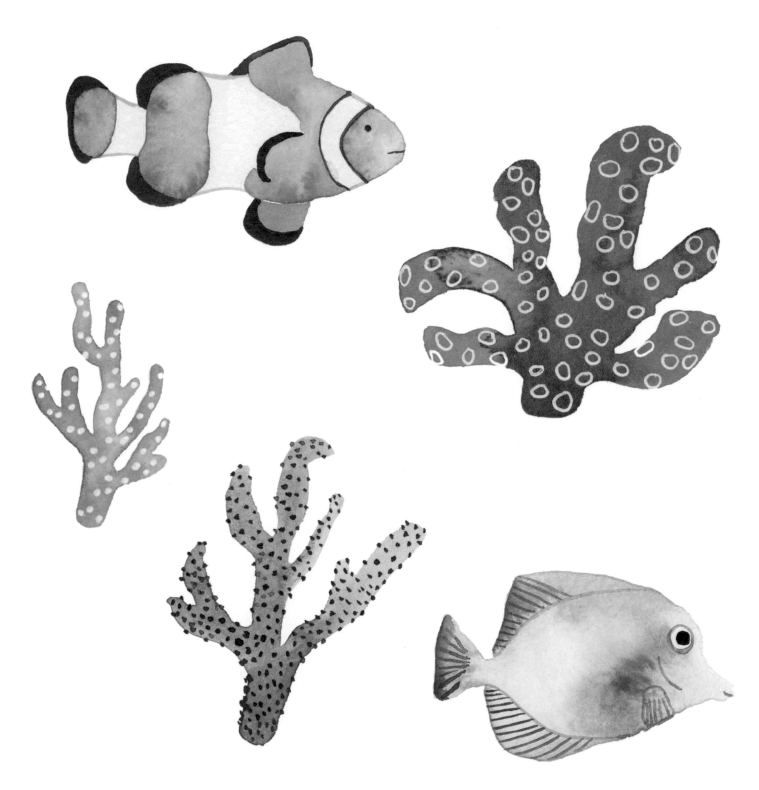

In the Jungle

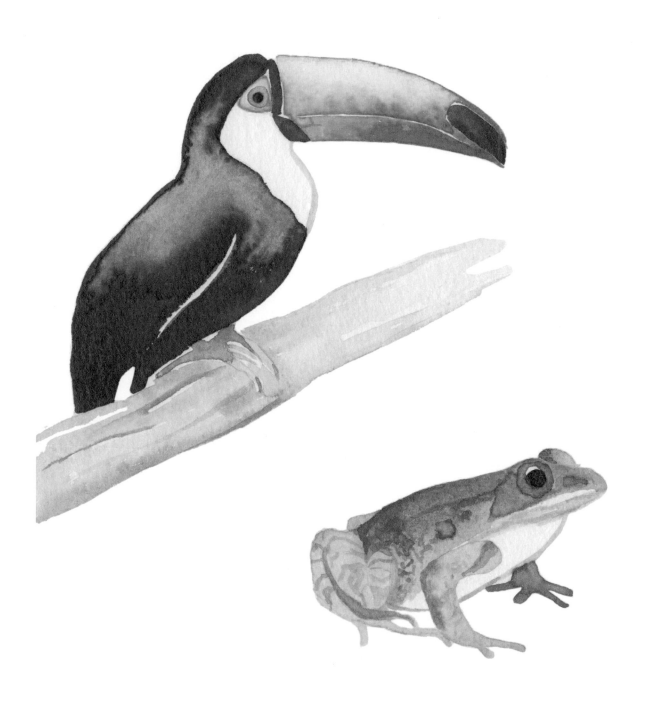

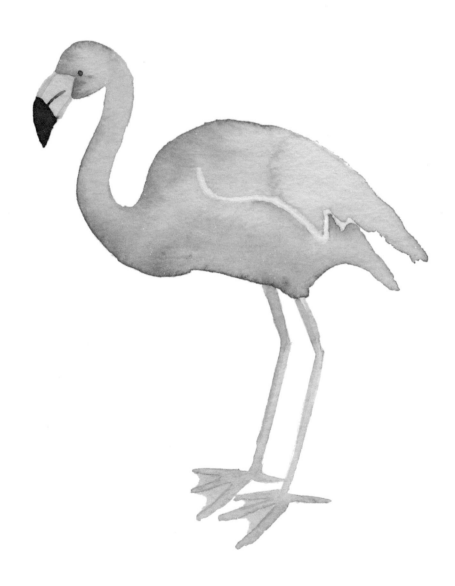

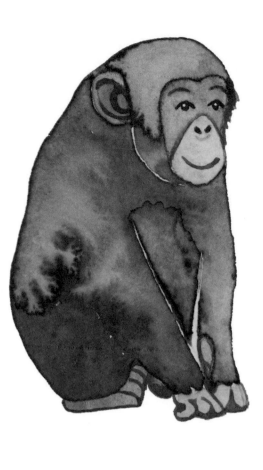

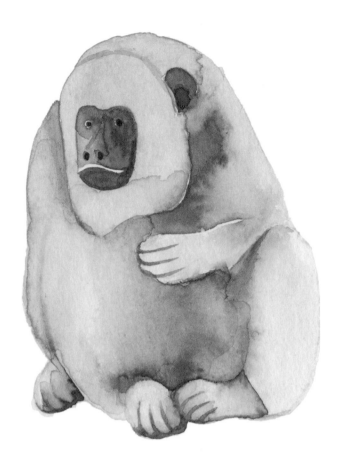

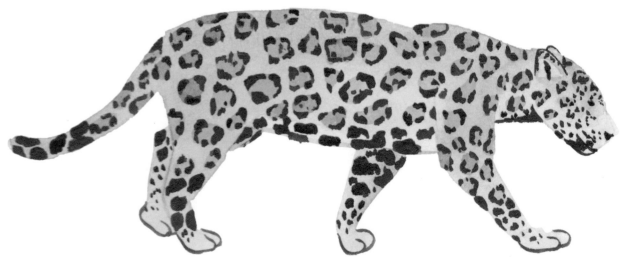

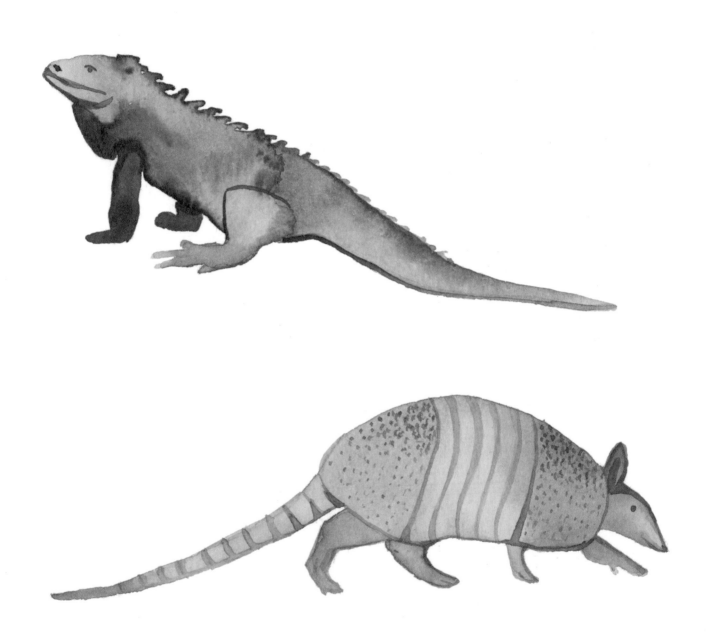

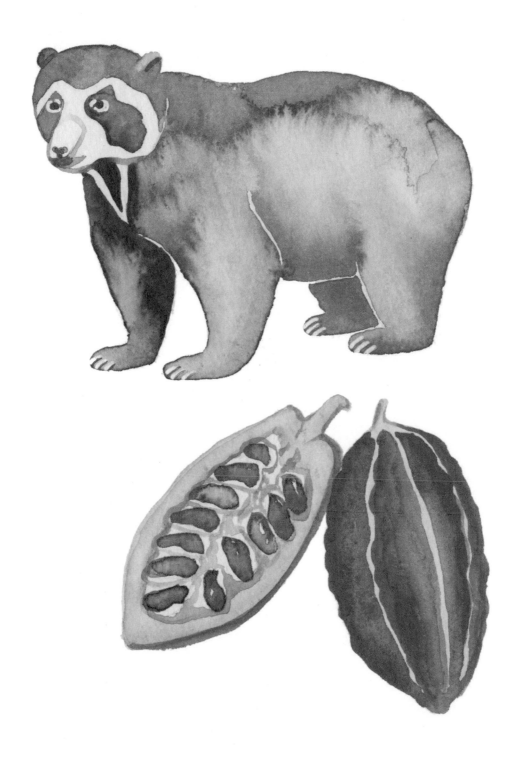

Fruit & Vegetables

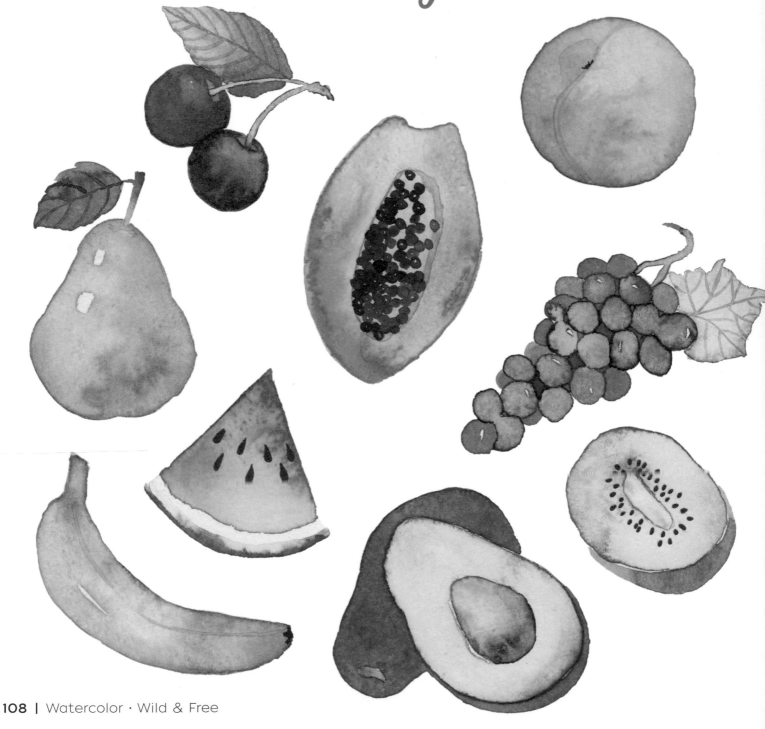

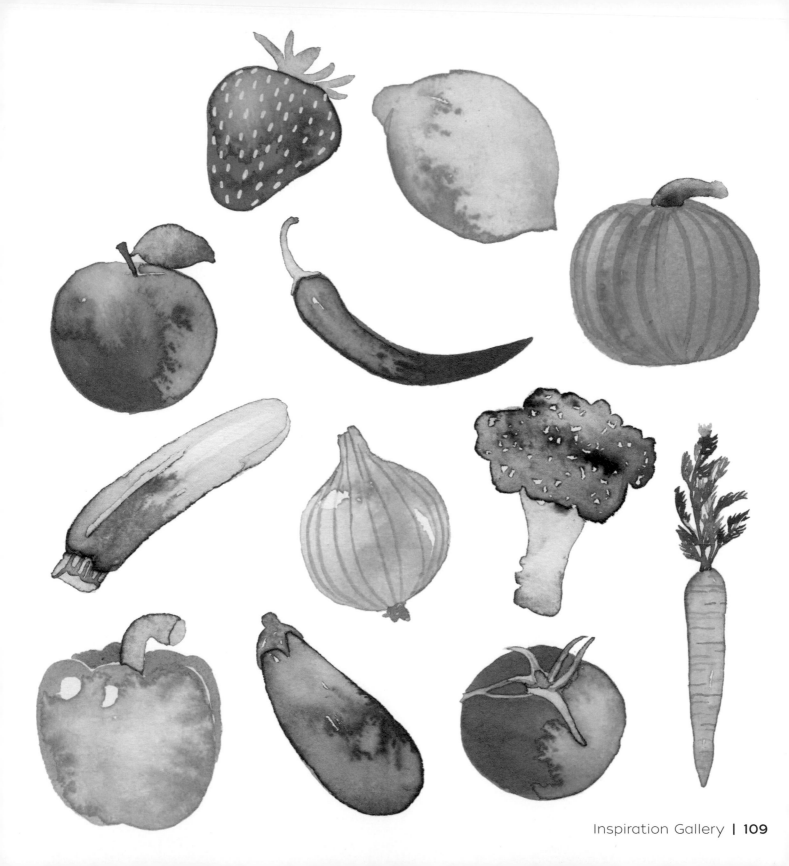

My Materials

I would like to thank the following companies for their kind support: da Vinci, Faber-Castell, Hahnemühle and Schmincke.

I have used the following products to complete the projects in this book:

Watercolor paint box Schmincke Horadam (small pans)

Chromium yellow hue deep 212
Aureolin hue 208
Indian yellow 220
Chromium orange hue 214
Magenta 352
Cadmium red medium 347
Indigo 485
Paris blue 491
Yellow raw ochre 656
Olive green 515
Olive green yellowish 525
Payne's grey blueish 787
Perylene green 784
Mahogany brown 672
Gold brown 654
Vandyke brown 669
Titanium opaque white 101
Madder brown 670

da Vinci brushes

Cosmotop Spin round brush sizes: 5/0, 0, 3, 5, 8, 12
Cosmotop Spin flat brush size: 14

Hahnemühle Watercolor paper

Watercolor postcard block 250g/m² coarse
Britannia 300 g/m² matt natural white 24 x 32cm
Cézanne 300 g/m² matt 24 x 32cm
Cézanne 300 g/m² matt 30 x 40cm

Faber-Castell

Kneadable rubber eraser
HB and B pencil
Uni-Ball Signo pen in white

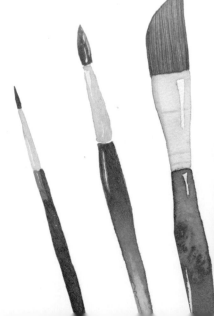

About the Author

Natalia Skatula was born in Loslau, Poland in 1989, grew up in Bad Wildungen, Germany and after graduating from high school studied History of Art with Fine Art and Artistic Design at Philipps University, Marburg. Here she gained insight into a number of working and painting techniques, including the foundations of watercolor painting.

However, her enthusiasm for watercolors grew after she completed her studies, when she began designing her first Christmas postcards using this technique. She has been working as a freelance illustrator and artist since 2018 and as a great connoisseur of paper, markets her Papetrie & Co. range of uniquely illustrated stationery items under the name nataskalia.

instagram.com/nataskalia · etsy.com/shop/nataskalia

Share your creative results using the hashtag #watercolorwildandfree

Index

A DAVID AND CHARLES BOOK

© 2019 frechverlag GmbH, 70499 Stuttgart

First published in the UK and USA in 2020

Natalia Skatula has asserted her right to be identified as author of this work in accordance with the Copyright, Designs and Patents Act, 1988.

The author and publisher have made every effort to ensure that all the instructions in the book are accurate and safe, and therefore cannot accept liability for any resulting injury, damage or loss to persons or property, however it may arise.

Names of manufacturers and product ranges are provided for the information of readers, with no intention to infringe copyright or trademarks.

A catalogue record for this book is available from the British Library.

ISBN-13: 9781446308264 paperback
ISBN-13: 9781446379820 EPUB

This book has been printed on paper from approved suppliers and made from pulp from sustainable sources.

Printed in China by Asia Pacific for:
David and Charles, Ltd
1 Emperor Way, Exeter Business Park, Exeter, EX1 3QS

10 9 8 7 6 5 4 3 2 1

David and Charles publishes high-quality books on a wide range of subjects. For more information visit www.davidandcharles.com.

Layout of the digital edition of this book may vary depending on reader hardware and display settings.